# 500
## Lighting
### Hints, Tips, and Techniques

RotoVision

A RotoVision Book
Published and distributed by RotoVision SA
Route Suisse 9, CH-1295 Mies
Switzerland

RotoVision SA, Sales & Editorial Office
Sheridan House, 114 Western Road
Hove BN3 1DD, UK

Tel: +44 (0)1273 72 72 68
Fax: +44 (0)1273 72 72 69
E-mail: sales@rotovision.com
Web: www.rotovision.com

10 9 8 7 6 5 4 3 2 1

ISBN: 978-2-940378-15-9

Designed by Fineline Studios
Art Director: Tony Seddon

Reprographics in Singapore by ProVision (Pte) Ltd.
Tel: +65 6334 7720
Fax: +65 6334 7721

Printed in Singapore by Star Standard Industries (Pte) Ltd.

# 500
## Lighting
### Hints, Tips, and Techniques

Rod Ashford

# Contents

## The Basics

## Working with Daylight

## Characteristics of Light

## Artificial Lighting

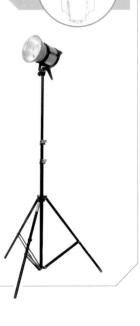

# Lighting Setups

# Postproduction Lighting

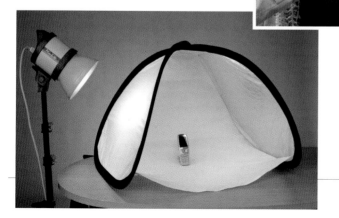

# Introduction

Anyone can instantly improve the look of their photos, simply by getting the lighting right. Good lighting can make a subject look better, but bad lighting will ruin any picture. No matter what equipment you're using, *500 Lighting Hints, Tips, and Techniques* will show you everything you need to know to take control of your own pictures, and avoid having to rely on your camera's automatic settings.

We'll look at how daylight works and how you can use your camera to capture beautiful images. At each stage, we'll give you just enough information to master a particular lighting technique; you won't have to trawl through pages of dull technical information! Any technical tips are clearly identified so you can skip them if you'd prefer.

Whether you want to take pictures of your friends using a cellphone camera, create stunning landscapes using a digital single-lens reflex camera, or shoot professional-looking product shots of items you want to sell online, this book will show you just how easy it is to get the light right. We'll also show you how to use computer software to correct the light if it wasn't quite perfect when you took your shot.

Daylight is the light by which we all see each other and everything around us. But daylight changes throughout the day, comes from different directions, is brighter at some times than others, and can change color from hour to hour. The sophisticated do-it-all program modes built into your camera can help you take great shots most of the time, all without needing any knowledge of how photographic lighting works. Unfortunately, while auto

settings are great for shooting in situations when the light is average, average lighting is never going to be the most exciting. In fact, it's often those times when the lighting doesn't look average that you're inspired to reach for your camera; all too often, this is when you'll find out that shooting on auto will make your pictures too light or too dark.

Whether you're shooting ordinary daylight, using small on-camera flashguns, or working with more advanced studio equipment, successful lighting is all about understanding the effects of light and knowing how to set up your camera to capture these effects. You'll never be able to control the weather, but once you understand how light works, you'll find it's easy to take control and make the light you've got more user-friendly.

Once you've mastered the basics, you'll soon find being creative comes naturally. Lighting can accentuate texture, mask imperfections, and enhance a subject's good points. Creative lighting is all about taking the effects of natural lighting and altering them so that anyone looking at your picture sees an unusual or new and exciting view of something quite familiar.

*500 Lighting Hints, Tips, and Techniques* takes you through choosing equipment, shows you how it works, and how to develop an eye for the quality of natural

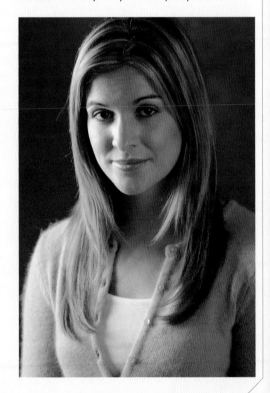

light. We'll look at how to make the most of on-camera flash, shooting with artificial light, and how studio flash equipment works; everything you need to know to get to grips with using lighting to shoot better pictures.

The book is organized into six sections. The first section looks at equipment, how cameras record the images you take, and the quality of everyday light. Section two looks at the characteristics of light; its color and brightness. Section three puts equipment and lighting together, concentrating on taking pictures in daylight. We also give you a few simple tips and techniques for changing the wrong light into the right light for photography. Section four explores every aspect of using artificial light, from on-camera flash guns to domestic lamps and studio flash equipment. Section five contains 12 easy-to-follow lighting projects, designed to show you how to tackle a whole range of photographic subjects with the minimum of equipment.

The last section looks at postproduction lighting techniques using inexpensive image-editing software on your computer. We look at the equipment and software you need, and explain the principles of image editing in a few simple tips. Once you've mastered the software basics, we show you a range of techniques designed to correct things when the light in a picture isn't quite right and how to enhance the lighting you've already captured. Finally, we'll show you how to create special digital lighting effects from scratch.

# The Basics

## Equipment, light quantity and quality

To be able to capture great pictures in all sorts of lighting conditions requires both an understanding of how light works and how your camera records it. Before looking at ways of modifying light, this section will examine how cameras capture images, the difference between automatic and manual cameras, and the effects these differences have on your photographs.

### 001 Compact cameras

In the past, the film versions of these point-and-shoot cameras were often associated with poor-quality images, but digital compacts are capable of delivering excellent picture quality. They feature sophisticated program modes, but the drawback is that they offer little or no manual control.

### 002 Prosumer cameras

These professional-consumer hybrid cameras usually have a fixed zoom lens and an electronic viewfinder. They not only offer excellent program modes, but also a high degree of manual exposure control. The picture quality offered by prosumer cameras is high.

## 003 Digital single-lens reflex cameras (DSLRs)

The design of these cameras has its roots in film photography. However, in the digital version, an electronic image sensor replaces the film. Light enters through the camera's lens and the image is reflected upward to the viewfinder by a mirror. When the shutter button is pressed, the mirror flips up allowing the light to reach the camera's image sensor.

## 004 Cellphones

Early camera-phones produced poor-quality images, but modern versions have much larger imaging sensors. As long as pictures aren't enlarged too much, image quality is quite good. Some cellphone cameras also offer a choice of shooting modes.

# How do cameras record the pictures your eyes see?

## 005 Image sensors

At the heart of every digital camera is its image sensor. This chip records the intensity and color of the light entering your camera's lens. Unlike film cameras, image sensors don't wind on after every shot; your camera has to store the image you've just captured on its memory card so the sensor is ready to capture the next image.

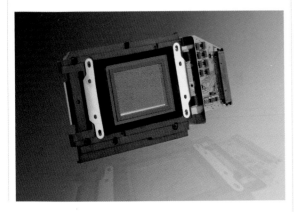

## 006 Low Pass filter

Depending on your camera's design, the image sensor will either be a CCD or CMOS chip. Technically they're quite different, but you probably won't see the difference in your pictures. Sensors can detect light wavelengths beyond human vision, so to make them suitable for photography there's a filter in front of the sensor. The Low Pass filter restricts the light the sensor can capture to within our visible spectrum. In cameras with removable lenses it also offers protection against dust falling on the sensor's surface.

## 007 Sensitivity

You can adjust the sensitivity of the sensor to make it more or less sensitive to light. For film cameras, to ensure continuity between film types, a film's sensitivity to light has an ISO rating such as ISO 100, ISO 200, ISO 1,600. This sensitivity rating has been carried over into digital cameras; the higher its ISO, the more sensitive it is to light. A camera's ISO settings are often referred to as its "speed." It is important to note that, although cameras are improving all the time, generally very high ISO settings can lead to more image interference, especially in low-light situations.

A

B

C

Picture A is too bright; there is too much light. Picture B is too dark; there is not enough light. Picture C has the correct amount of light.

## 008 Get the light right

To record a picture properly, the correct amount of light must be recorded by the image sensor. Too little light and the picture will be too dark, too much light and the picture will be too bright.

## 009 Exposure

Pressing the camera's shutter button opens the camera's shutter and exposes the image sensor to the light. This is known as making an "exposure."

## 010 Finding the "correct" exposure

Although an exposure might often be described as "the correct exposure," it's actually very much a matter of personal preference. Some people like to slightly underexpose their pictures (make them darker) to saturate colors, while others prefer to overexpose their pictures (make them lighter) to perhaps lighten the skin tones in a portrait. Experiment with both to find out which suits your photographic style best. For the purposes of this book, we'll use the term "correct exposure" to mean a picture looks the way the photographer intended it to.

## 011 Controlling the exposure

A correct exposure needs just the right balance between the amount of light reaching the sensor and the length of time the light is on the sensor. There are two ways to control exposure—aperture and shutter speed.

## 012 Aperture

An aperture is basically an opening. In photography, it's the term applied to the hole in the lens where the light passes through to record the picture. All camera lenses have an aperture; some cameras allow the user to control the size of the aperture and so control how much light can pass through.

## 013 Setting the aperture

Digital cameras adjust the aperture electronically, so the days of having to twist a ring on the front of the lens have long gone; some DSLR lenses still retain this option, but it's unlikely you'll ever need to use it.

## 014 Technical: f/stops

The size of the aperture is called an f/stop. An f/stop is not the physical size of the hole, but is the term used to describe a ratio between the focal length of a lens and the maximum aperture available. For example, a 50mm lens might offer a largest aperture of 25mm. Fifty divided by 25 is two, so therefore the maximum aperture of that lens is described as f/2.

## 015 What the numbers mean

Large apertures have small f/stop numbers, small apertures have large f/stop numbers, so the smaller the hole, the bigger the f/number. For example, f/22 is a small hole and lets in very little light.

## 016 Maximum aperture

A lens with a maximum aperture of f/1.4 is described as a fast lens because it lets in more light and is useful in low-light conditions. Due to their superior design, fast lenses are generally quite expensive.

 **F/stops are standard**

Typically, the f/stops found on camera lenses are: 1.8, 2.0, 2.8, 4, 5.6, 8, 11, 16, 22. The focal length and maximum aperture available are usually printed on the front of the lens.

**018 Fine adjustments**

Electronically controlled shutters often offer in-between apertures of 1/3 or 1/2 f/stop increments, which helps you to get the right exposure (see tip 010).

**019 Changing f/stops**

Changing from one f/stop to another is called "stopping up" when switching to a larger aperture, or "stopping down" when changing to a smaller aperture.

**020 Shutter speed**

The shutter opens to let the light coming through the lens reach the imaging sensor and closes again to shield the sensor. Cheaper cameras usually have a fixed speed to open and close the shutter to let the light through. Shutter speed values are expressed as fractions of a second such as 1/30, 1/60, 1/200, or even whole seconds, such as 1 second or 4 seconds.

**021 Technical: the law of reciprocity**

Although the title of this rule sounds complicated, the law of reciprocity simply states that any change in aperture can be compensated for by an opposite change (reciprocal) in exposure time. Basically, this means there's more than one way to make an exposure!

**022 Why is this important?**

The relationship between aperture and shutter speed is really important if you want to capture shots in low light (see tip 030), or freeze a moving subject (see tip 028). A small aperture left open for a long time will let in the same amount of light as a large aperture opened for a very short period of time.

## 023 Reciprocity in action

Using an aperture of f/11 with the shutter open for 1/125 second is the same as using the smaller aperture f/16, but with the shutter staying open for the longer time of 1/60 second. This also works if you stop up to a larger aperture of f/8; you'd need to decrease the exposure time to 1/250 second.

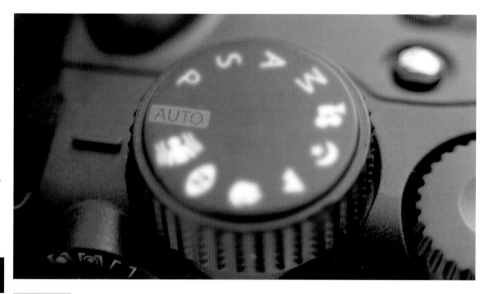

| f/5.6 | f/8 | f/11 | f/16 | f/22 |
|---|---|---|---|---|
| 1/500 | 1/250 | 1/125 | 1/60 | 1/30 |

## 024 Using the Bulb setting

Most DSLR cameras have a Bulb (B) setting which allows the shutter to remain open as long as the shutter button is held down. This is useful for making long exposures in low light, but you'll need to use a firm support to hold the camera steady.

## 025 Using the Auto setting

If you use your camera's Auto setting, a sensor in the camera will detect the brightness of the light and automatically set a combination of both aperture and shutter speed for you. In the majority of shooting situations this will result in well exposed pictures, but like any mechanical function it's not foolproof (see tip 061).

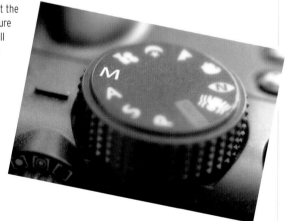

## 026 Using the Manual setting

The Manual setting allows you to select both aperture and shutter speed. This can be really useful when you're shooting in situations where the camera's Auto setting cannot set the correct exposure (see tip 061), or if you're working with studio flash lighting (see section 4).)

##  Should I adjust aperture or shutter speed?

If the same amount of light reaches the sensor at various aperture and shutter speed combinations, you might ask why you'd want to have a choice of which combination to use. The answer is, that shutter speed and aperture each have an effect on the way a picture is captured.

##  Freezing movement

Use a fast shutter speed when you want to freeze a moving subject. A sports photographer, for example, would need a shutter speed of 1/1000 second, or faster, to successfully capture action shots.

## 029 Blurring movement

Shutter speeds slower than 1/500 second will make a moving subject appear blurred.

## 030 Shooting in low light

A slow shutter speed is useful for gathering a lot of light, which is great for low-light shooting, but it's very hard to hold a camera steady with shutter speeds slower than 1/60 second. When shooting with slow shutter speeds, a tripod is essential.

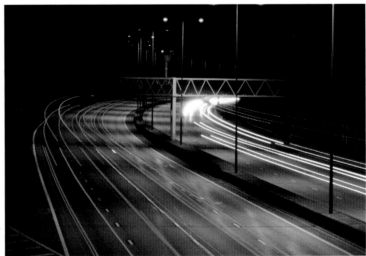

## 031 Camera shake

The blur associated with moving the camera during an exposure is called "camera shake." Many cameras will display a warning if there's a risk of camera shake.

## 032 Avoiding camera shake

To avoid camera shake, you can either use a shutter speed faster than 1/60 second, or use a tripod to steady the camera and a remote shutter release to press the shutter button without moving the camera.

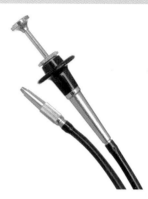

## 033 Shutter release

A remote shutter release is a cable that attaches to the camera's shutter button and remotely triggers it, either electronically or manually, via an extending pin that literally trips the shutter button.

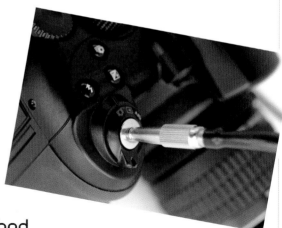

## 034 Self-timer method

If you have a firm support for the camera but you can't connect a remote shutter release, you can still minimize the risk of moving the camera as you press the shutter button by using the camera's self-timer function to trip the shutter.

# A word or two about tripods

## 035 Tripods

A tripod offers a firm three-legged support for a camera. Almost every camera has a tripod mount on its underside. Tripods come in various sizes and weights but they're not all suitable for the same jobs. The size and weight of your camera is an important factor; a tripod has to be capable of supporting your camera without it toppling over.

## 036 Choosing a tripod for studio work

If you intend using a tripod just to keep your camera in one position while you arrange your studio lights, you won't need a particularly heavy-duty model.

## 037 Choosing a tripod for low-light conditions

To keep your camera steady in an outdoor, low-light situation, you'll need a tripod that won't wobble, or worse still, blow over in a brisk wind.

## 038 Choosing a tripod for outdoor work

A tripod for outdoor use has to be sturdy enough not to shake, but portable enough to carry along with all your other photographic equipment. What starts off as a modest weight, can soon become extremely heavy if you have a long way to walk to get to your shooting location.

## 039 Choosing a tripod for tabletop shots

The height of the tripod is an important consideration. If you're going to shoot a lot of tabletop shots, you'll need a tripod that will extend high enough to look down on the table. Otherwise you will find yourself working at floor level, where it's difficult to position any lighting and you'll get backache from bending over to look through the camera.

## 040 Choosing a tripod for a lightweight camera

If your camera is lightweight, a miniature tabletop tripod is a good option.

## 041 Bean bag supports

For low-light shots outdoors, a bean bag support is an extremely versatile way to steady your camera. Easily carried in a camera bag or even in your pocket, a bean bag can be shaped to fit pretty much any shooting location.

## 042 Monopods

A monopod is useful for holding a camera steady; it's a bit less effective than a tripod in low light, but it's a lot steadier than trying to hand-hold your camera.

# 043 Plane of focus

Your choice of aperture affects how much of a picture appears to be in sharp focus. When a lens is focused on a subject, everything in the picture along the same plane as the subject will be in focus.

# 045 Shallow depth of field

A large, wide-open aperture such as f/2 offers very little depth of field and only the object focused on appears sharp. In the picture on the right, the pink pencil is sharp but the others are progressively out of focus.

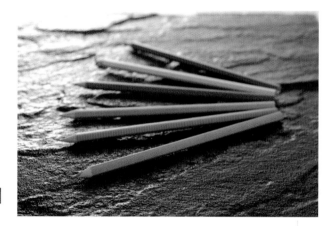

# 044 Depth of field

The area that appears sharp in front of and behind the plane of focus is called the depth of field.

# 046 Maximum depth of field

Smaller apertures such as f/16 or f/22 offer the greatest depth of field with objects in front of and behind the subject all appearing sharp (see the picture below).

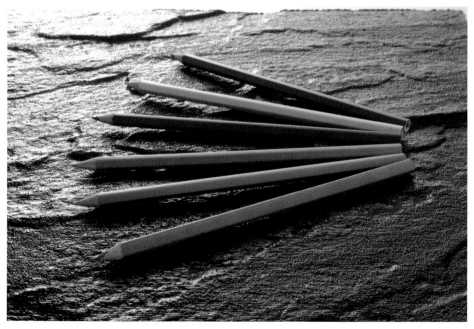

# 047 The 2:1 rule of thumb

As a general rule, the ratio of apparent sharpness between objects in front of and behind the subject is roughly 2:1, with one third in front of the subject and two thirds behind. This is useful when trying to achieve maximum sharpness in varying lighting conditions. The example below was taken at f/8. With the orange pencil as the point of focus, there is enough depth of field to make all of the pencils appear sharp.

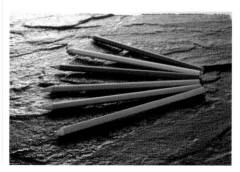

# 048 Program shooting modes

Some cameras have a choice of Program shooting modes, where you can tell the camera to make either the aperture or the shutter speed its priority when calculating an exposure. These programs can be optimized for sports or portrait photography, but still allow some degree of user intervention.

# 049 Using the A setting

An A setting allows you to set the aperture, but lets the camera select an appropriate shutter speed. This mode is useful if you want to control the depth of field.

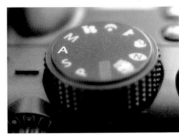

# 050 Using the S setting

An S setting allows the photographer to select a shutter speed while the camera sets its own aperture. Use this to freeze action or reduce the risk of camera shake.

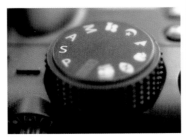

# 051 Portrait mode

As its name suggests, this mode is optimized for shooting portraits of people or animals. The camera will give priority to larger apertures to throw the background out of focus by minimizing depth of field.

# 052 Landscape mode

Onboard flash is usually disabled in this mode. The camera gives priority to smaller apertures to maximize depth of field.

# 053 Sport mode

This mode gives priority to shutter speed. Selecting a fast shutter speed will freeze sports action or a moving subject. However, in lower-light situations, depth of field will be minimal.

Image copyright Richard Horley

## 054 Nighttime mode

Priority is given to slow shutter speeds up to 3 or 4 seconds, so a tripod is essential when using this mode.

## 055 Fireworks mode

This mode will give priority to a slow shutter speed that can be selected by the user within the range 1/2 to 4 seconds. You will need to use a tripod to avoid camera shake.

## 056 Other modes

Some cameras also offer modes for shooting in outdoor conditions where a bright background such as sand, snow, or sky can make the camera's exposure meter think the scene is brighter than it really is (see tip 127).

Bracketing in 1/2 f/stop increments.

## 057 Exposure Value (EV)

Exposure Value (EV) is the number given to represent the brightness value of various shutter speed and aperture combinations at a given film speed. With digital cameras offering easy ISO adjustment and even auto ISO settings, actual exposure values are less relevant than EV adjustments.

## 059 Bracketing

Bracketing is the term used to describe a technique for taking a number of pictures of the same subject, each with slightly different exposure settings. You can use this for creative effect or in situations where it's difficult to assess the correct exposure just by looking at the camera's LCD preview.

## 058 Exposure compensation for high contrasts

The exposure compensation button +/- EV offers some fine control over the camera's auto program modes. The camera's suggested exposure settings can be overridden up to +2EV (2 f/stops more) or -2EV (2 f/stops less) in increments of 1/3 f/stop to allow for subjects where the contrast range is higher or lower than normal, such as bright skies or dark trees.

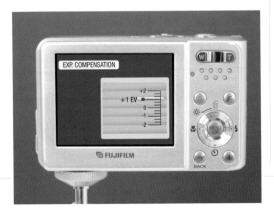

## 060 Autobracketing

Some DSLR cameras offer an autobracketing function. The photographer can set the number of frames and the amount of over or underexposure to use, in increments of full f/stops, 1/3 f/stops, or 1/2 f/stops.

# Measuring light with in-camera light meters

## 061 Running on Auto

Set to Auto or Program mode, the onboard metering system built into your camera will produce well-exposed pictures with a very high rate of success. Cameras offer various methods of measuring light and determining a suitable combination of aperture and shutter speed.

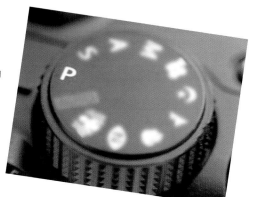

## 062 Multi mode

Separate through-the-lens (TTL) light readings are measured from points all over the subject in the camera's viewfinder and compared with a databank of stored exposure examples. Using this method, a camera can accurately predict the best exposure settings for the majority of shooting situations.

## 063 Spot mode

This mode measures the light in a small circle (spot) in the middle of the viewfinder. It is sometimes referred to as Center Weighted mode.

## 064 Average mode

In this mode, the camera takes various readings from around the scene in the viewfinder and works out an average exposure value for the whole scene.

## 065 It's not all plain sailing

Unfortunately, there are drawbacks to using even the most sophisticated in-camera metering systems. Onboard meters measure the light reflected back from a subject, rather than the amount of light falling on to it.

## 066 Shades of gray

All in-camera meters are designed to measure an average reflectance of 18 percent gray: a light to mid-gray color. It doesn't matter what tones are in a scene: your camera sees them as gray. Although for the majority of everyday shooting conditions this will give you correctly exposed shots, it can cause a problem if your scene contains light or dark tones that don't reflect 18 percent gray. The following tips look at this in more detail.

## 067 Gray cards

A gray card can either be a solid gray with 18 percent reflectance or a series of gray tones. If you include a shot of a gray card when you start shooting in a particular lighting situation, you will be able to accurately adjust the tones in your shots using picture-editing software on your computer.

# 068 TTL isn't foolproof

When you're shooting a subject that's lit from behind (back-lit) or from the side (side-lit), a TTL metering system will detect the very different light levels in the scene. This causes the metering system to either try to compensate for the brightest areas or the darkest, leading to under or overexposure.

# 069 Get it white

If the principal subject of your picture contains a lot of white, such as a snow scene or a bride's white dress, a TTL metering system will want to select an exposure that will record the detail as 18 percent gray (see tip 066). This means your pictures will be underexposed and look too dark. Tip 073 shows you one way to get around this effect.

## 070 Back to black

If the scene you're shooting contains a lot of black, the camera's metering system will try to expose this as 18 percent gray, too. This will cause your picture to be overexposed and much too bright.

## 071 When TTL goes wrong

The pictures below show the effect of a camera's metering system when presented with a bright sky and a dull foreground. The meter either suggests an exposure that records the sky correctly and the foreground too dark (left), or the foreground correctly and the sky too bright (right).

## 072 No room for creativity

One final drawback to TTL metering is that your camera's metering system cannot know when you are being creative. Although you may want a little more exposure in the shadow areas, the camera will always suggest exposure settings that will produce the best average across the tonal range of the subject.

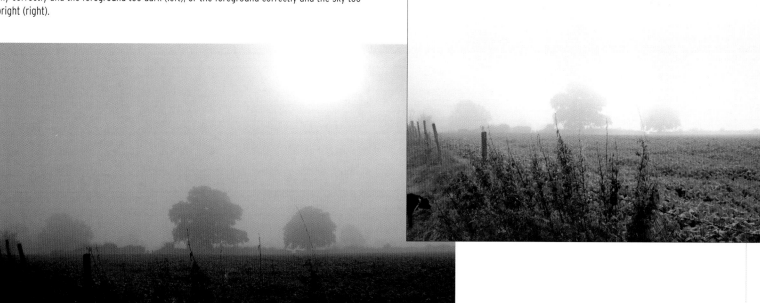

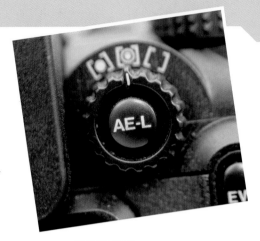

##  Auto Exposure Lock (AE-L)

An Auto Exposure Lock (AE-L) function allows you to take a light reading from one part of a scene and then lock that setting as the exposure for the shot. Pressing the AE-L button forces the camera's light meter into Spot or Center Weighted mode and takes a reading from the circle at the center of the viewfinder, with slightly more emphasis toward the bottom of the circle.

##  Using AE-L

Point the center of the viewfinder at the area you want to measure and hold down the AE-L button. As long as the button remains depressed, the camera will use that exposure setting.

##  Using a gray card

If you have a gray card, you can zoom in and focus the camera on it to let the camera's metering system suggest an exposure based entirely on a mid-tone. Then use AE-L to hold this exposure setting while you recompose the shot.

##  Meter for mid-tones

As the grass in the foreground of this scene is a mid-tone, a shot using AE-L based on a meter reading from the grass produces the best exposed shot (B), with both the sky and the trees looking natural.

##  Incident meters

For creative control over measuring the lighting on a subject, a hand-held incident meter is essential. An "incident" light reading is a measurement of the actual light falling onto the subject rather than the light reflected from it.

## Digital technology

Incident meters use digital technology and have LCD screens to display exposure settings.

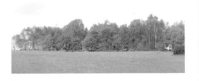

A

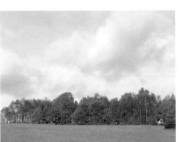

B

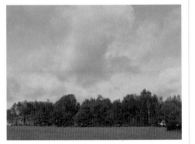

C

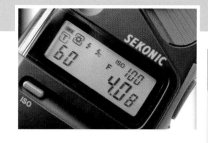

## 079 Digital accuracy

Light meters are accurate to 1/10 f-stop, although some only provide a display accurate to 1/3 f/stop.

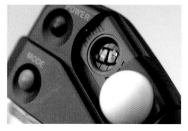

## 080 Synchronize your camera and meter

To be able to correctly measure the light and display a suggested exposure setting, the meter needs to know the ISO speed set on the camera.

## 081 Directional

The light meter has a light-gathering lens, which measures only the light entering the lens. This is really useful for taking precise measurements around a scene, but isn't so useful for measuring the overall lighting levels.

## 082 Invercones

An "Invercone" is a translucent dome that slides across the light-gathering lens to average out the intensity of the light entering it from all sides. To take a light reading, hold the meter in front of your subject with its Invercone pointed toward the camera and press the measurement button. The meter will then suggest an exposure setting based on the overall brightness of the light striking the subject.

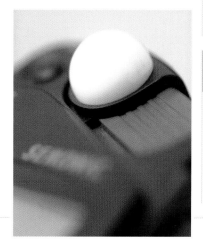

## 083 Metering for shadows and highlights

Many photographers take incident readings from the brightest and darkest areas of the subject and make their own decision as to their preferred exposure. This might be to ensure detail is held in highlight or shadow areas, or purely for creative effect.

## 084 Filter factor

Filters used for creative effect reduce the amount of light entering the camera's lens. Exposure compensation can be calculated using the "filter factor" supplied with the filter, but it's easier to simply hold the filter over the meter's Invercone and take a light reading.

## 085 Spot metering

A spot meter or spot meter facility is really useful for making an accurate measurement of the light from a single, tiny area of the subject, a "spot." A meter with a spot function has a viewfinder through which the photographer can see a very precise area of the subject and measure the amount of light reflected from it.

## 086 Accurate metering

It's very unlikely that a single spot reading can be used as a guide to exposure on its own. However, by taking a number of spot readings from all around the subject, or by combining a spot reading with an incident reading, you can get an accurate prediction of how the subject will be captured and make any exposure adjustments necessary to ensure the correct result.

# Characteristics of Light

## Learning to "see" light

Photographers need to be able to "see" the effects of the natural light around them. The human brain tends to interpret different real-life lighting situations and just accept everything as a sort of overall white light, but your camera can see what's actually there, and will record everything—even if it's not what you really wanted. To be able to photograph the effects of beautiful lighting requires not only an understanding of the color and texture of light, but also the ability to use your camera to record a scene the way your eyes see it.

### 087 The visible spectrum

The visible spectrum of light is made up of different wavelengths between 400 and 700 nanometers (nm). The predominant colors are red, blue, and green, which when viewed simultaneously in equal amounts appear to our eyes as white. The exact mix of colors can vary from one light source to another, but our eyes generally interpret all blends as being white, unless we're making a specific comparison.

### 088 Visual awareness

The color of light changes throughout the day; the light at early morning and late evening is a very different color to the light at midday. To be able to capture an image that's more than just a simple record of a scene, you need to develop an awareness of the color of light. The color of light varies across the globe, which is why professional photographers often have to travel to far away locations and shoot at unsocial hours to capture the exact lighting effects they want.

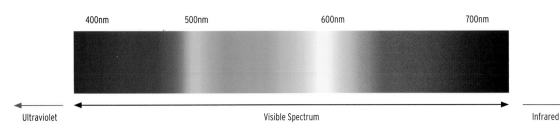

| 400nm | 500nm | 600nm | 700nm |

Ultraviolet          Visible Spectrum          Infrared

## 089 Color and mood

The color of the light in a photograph plays an important part in the way people view it. Orange or yellow light can look restful or homely; we describe these colors as "warm." Blue or gray light can have the opposite effect, making a scene look cold and uninviting; we describe these colors as "cool" (see tips 091 and 092).

## 090 Color casts

Artificial light sources such as domestic tungsten lamps or fluorescent tubes each have their own color too. Household lamps make everything look a grubby orange color and fluorescents give off a greenish glow.

## 091 The Kelvin scale

The color of light is described as its "temperature" and is measured in degrees on the Kelvin (K) scale, an old-fashioned scale which actually has to do with heating black metal until it glows different colors as the temperature increases.

## 092 Kelvin scale: examples

Light on an average shady day is very blue and would measure around 8,000 K, whereas early morning or late afternoon light is much warmer at around 3,500 K. A domestic lamp is around 2,800 K.

## 093 The color of daylight

Color film used to be nominally balanced for daylight and electronic flash, both of which measure around 5,500 K. This figure is now nominally used for digital cameras too.

Candlelight 1,000 K

Sunrise or sunset 2,000-3,000 K

Household light bulb 3,000-3,500 K

Studio photoflood bulbs 3,200-4,000 K

Early-morning or late-evening sunlight 3,500-4,000 K

Midday sunlight 5,400 K

Electronic flash 5,500-6,000 K

Cloudy or overcast 6,000-7,000 K

Open shade 7,000-8,000 K

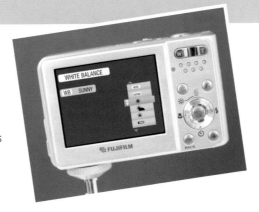

## 094 White balance

How your camera sees the color of light is controlled by setting its "white balance." Cameras are usually set to auto white balance, which means the camera automatically detects the color of the light just as the picture is taken and adjusts its white balance accordingly.

## 095 Manual control

Some cameras offer more control over the white balance settings for shooting situations where the camera has trouble detecting the correct color balance, such as close-ups of faces or a bride's white dress on a dull day when the light appears very blue.

## 096 Tungsten bulb setting

The tungsten bulb setting adds blue to the overall picture to balance the orange glow of the light with a more natural color balance.

## 097 Blue filter effect

The tungsten bulb setting can be used for creative effect, similar to putting a blue filter in front of the lens. The effect works well with some subjects but it's largely a matter of personal preference. Experiment with different shooting situations to see what works, but don't forget to reset the camera afterward, or all your subsequent pictures will appear far too blue.

## 098 Cloudy day setting

Using the cloudy day setting will add a little warmth to the overall color balance to compensate for the overall blue hue of the light.

## 099 Fluorescent light

Fluorescent tubes all give off a green light in varying strengths. Most cameras offer white balance settings for cool white, warm white, and daylight tubes.

## 100 Customizing white balance

If your camera has a custom white balance setting (or two), you can use this to manually set the white balance and exposure. Hold a piece of white paper under the lighting conditions you want to measure and zoom the lens until the white paper fills the screen. Press the shutter button to register the white balance and exposure setting. Make a test picture and check it on the camera's LCD screen to make sure everything is working the way you want before taking any important shots.

## 101 Color temperature meters

Color temperature meters are pretty specialized and can accurately measure the color of light. But they are expensive and probably more suited to film photography where accurate color reproduction is vital, so think carefully before purchasing one for digital photography.

## 102 Using color correction (CC) filters

You can use color correction (CC) filters to compensate for any color imbalance in a light source. These can be used over the camera lens or in front of an artificial light source, but setting up a manual white balance in the camera is easier and more accurate.

# Contrast

## 103 What is contrast?

The difference between the lightest and darkest tones in a photograph is described as "contrast." As light strikes a surface it is either absorbed or reflected in varying intensities. A white shirt, for instance, reflects a lot more light than a pair of black pants. Understanding contrast and learning how to control it is an essential lighting skill if subjects are to appear to have three-dimensional shape and form in a two-dimensional photograph.

## 105 Low contrast

A low contrast picture contains predominantly mid-tones, with very little highlight or shadow. Low contrast pictures are usually described as looking "flat."

## 104 High contrast

A high contrast image is one in which the lightest and darkest tones dominate the mid-tones. The ultimate high contrast picture would contain only two tones: solid black and solid white.

## 106 Highlights

The brightest areas of a picture are called the "highlights." For a photograph to look natural, it needs to contain a complete range of tones, from brightest highlights through to deepest shadows. The shot on the left contains predominantly highlights and shadows as the camera's TTL metering was unable to set a correct exposure (see tip 068).

## 107 Specula highlights

When you point light at a shiny surface, the light is reflected back at almost its full brightness. This causes the reflection to overexpose; the result is a very bright white highlight spot that can obscure detail in the subject. Point reflections like this are called "specula highlights."

# Hard and soft light

## 108 Hard light

"Hard" light is characterized by the bright highlights and deep shadows produced by a relatively small light source. Anything placed in the path of the light will cast a strong, dark, crisp-edged shadow.

## 110 Flat lighting

The contrast between highlight and shadow detail can be difficult to photograph and some detail can be lost. Sometimes a camera's metering system may try to reduce the scene's overall contrast and make the picture look a bit flat (see tip 071).

## 109 Shadow effects

Shadow effects are most noticeable around midday on a bright sunny day when the sun is at its highest in the sky.

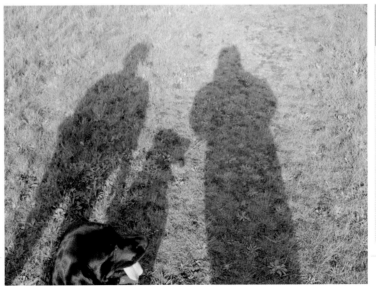

## 111 Soft light

"Soft" light is characterized by low contrast across the tonal range with fuzzy-edged and almost indiscernible shadows. A soft-light effect would be typical of that seen on an overcast day. Shots taken using only soft light have a tendency to look flat, however there is no loss of detail in the captured picture.

# Direction and angle

## 112 Light constantly changes

When shooting outdoors, remember that the sun is constantly moving, so its position relative to your camera and your subject changes. The light could be straight in front of the subject, directly behind it, or striking it at an angle; everything you photograph will look different when lit from different angles. Watch how the light works with your subject and be ready to capture the image when the light looks just right.

## 113 Shape and form

Depending on its direction and angle, the lighting will reveal something about the subject. Frontal lighting tends to make objects look less three-dimensional and flat, while side lighting reveals texture.

## 114 Wait for the moment

Professional landscape photographers will always visit a location before trying to photograph it. If necessary they'll spend a whole day observing how the light at different times changes the look of the landscape. To capture a truly inspirational shot might take days of waiting for the perfect weather conditions and even when the light is right, that exact moment may only last a few short minutes.

## Diffusion

### 115 Point light source

The high contrast and dark, hard-edged shadows associated with direct sunlight are characteristic of lighting from a "point light source." A tungsten spot lamp or flash gun are also point light sources.

### 116 Spot lamps

Artificial point light sources like spot lamps produce the hardest lighting, as even the harshest sunlight will have been diffused to some degree by the earth's atmosphere.

### 117 Diffusing light

Translucent material placed in the path of a point light source disrupts its rays, scattering them over a greater area and making the source of the light appear to be much larger. If you diffuse the light in this way, it softens the edges of its shadows and reduces contrast by decreasing the light's intensity.

### 118 A passing cloud

If you're shooting on a sunny day, wait for a cloud to pass over the sun. This will diffuse the sun's rays, producing a much more flattering, soft diffuse light.

## Reflection

### 119 Shadowless

Solid surfaces reflect light with varying degrees of efficiency. Reflected light has a very soft quality with almost indiscernible shadows.

### 120 Natural reflectors

When you shoot outdoors, you will find numerous reflective surfaces that naturally soften daylight, such as sand or snow. Indoors, light colored walls or even white tablecloths can be used to reflect an overhead spot lamp to soften unattractive shadows. But it's important to bear in mind that brightly colored surfaces will not only reflect light, they can also reflect their color as well, which might not always be the best kind of lighting for shooting portraits.

# Working with Daylight

## Modifying daylight

In general, pictures lit using only one type of lighting have a tendency to look quite unnatural. Our eyes are used to seeing the three-dimensional world around us illuminated by mixtures of hard and soft, diffuse and reflected light. This section looks at shooting in daylight and, while we can't claim to control the weather, offers a range of tips and techniques for turning ordinary daylight into photographic lighting.

### 121 Controlling daylight

Once you understand how to measure light and control contrast, and have mastered the techniques of modifying light through diffusion, reflection, or by simply restricting its spread, your photography will be limited only by your imagination.

### 122 Keep an eye on the weather

One of the first things photographers learn about working with daylight is that it's unpredictable. All the technique and experience in the world won't help when the weather is bad. Technique can help you make the best of a bad job, and in some cases it just might save the day, but generally, if you're going to work with daylight you'll either need to plan your shots around the weather forecast, or make sure you've got some artificial light to act as a backup.

### 123 Don't make your subject squint

In the earliest days of film photography, photographers needed as much light on their subjects as they could get. This led to a myth that subjects should be positioned so that the sun is behind the photographer; that is, with the sun directly in your subject's face. It's true that this will prevent the sun from causing flare in your lens, but you should be aware that shining a bright light in your subject's eyes will make them squint.

### 124 Try lighting from the side

A better alternative is to position your subject with the sun to the side; but even this will create shadows on your subject's face.

### 125 Think about the background

Dark trees in the background of shots create a dull feel to portraits, so try to avoid them unless you're aiming for a "moody" portrait. When shooting in a wooded area, try positioning your subject so that the sky acts as a more pleasant backdrop.

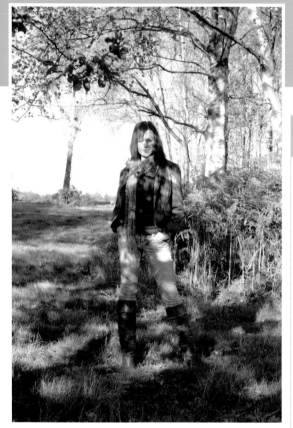

## 127 Balance brightness levels

Turning your subject away from direct sunlight means that the background will be much brighter than the subject. Unless the subject almost completely fills the viewfinder, your camera's metering system will usually try to expose for the brightness of the background, making the subject too dark. If you take a meter reading directly from the subject and use AE-L, the subject will be correctly exposed but the background will be overexposed; without some extra lighting, you'll never balance the two. The following tips look at ways to inject a little more light onto your subject.

## 126 Avoid ugly shadows

If you are shooting in bright sunlight, placing your subject in a shady position, under a tree for example, is likely to lead to unwanted shadows on their face.

# Reflectors

## 128 Choosing a reflector

Outdoors, there are numerous natural light reflectors, such as sand or white walls. For something more portable, purpose-made reflectors are widely available in various shapes and sizes.

## 129 Efficiency

The surface of the reflector has an effect on the quality and color of the light it reflects. A shiny silver surface will reflect harsher, crisper light, while a crumpled or matte silver surface scatters the reflected light, reducing its intensity and softening it.

## 130 Mirrors don't work

You can't really use a mirror as an effective reflector as it will only reflect the same quality of light that hits it. A point light source reflected in a mirror will simply be reflected as a point light source. An efficient reflector needs to spread and soften the light's rays.

## 131 Size is important

In general, if you're photographing people, an efficient reflector needs to be roughly 24in square (60cm²) or larger.

## 132 Make it yourself

You can make a simple reflector using white foam core board or white cardboard. A white reflective surface produces soft, neutral reflections.

## 133 Increased effect

For a crisp, bright effect, use aluminum foil carefully stuck to a piece of foam core board or cardboard.

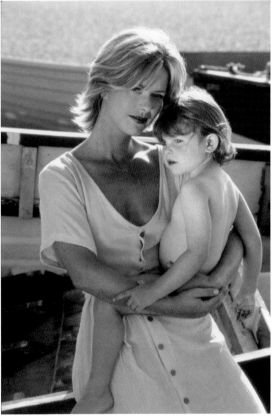

## 134 Scatter the light

To make the light even softer, crumple the foil to scatter the reflected light rays and reduce its intensity.

## 135 Instant sun tan

A gold surface gives the reflected light a warm glow, which is useful for warming up skin tones.

## 136 Negative reflector

A black surface acts as a negative reflector. Black absorbs the light preventing any fill in.

## 137 Purpose made

There are numerous advantages to using commercially made reflectors: they're usually made from weather-proof fabric, they fold down into an easily transportable carry bag, and some can be fitted with interchangeable fabrics depending on whether you need a white, silver, or gold lighting effect.

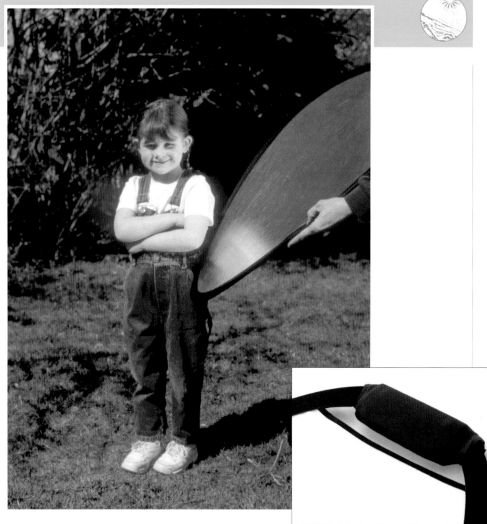

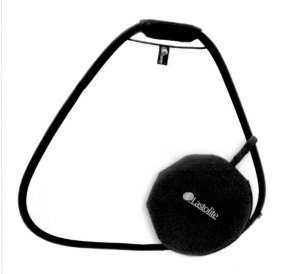

## 138 Assistants

Working outdoors with a reflector can be tricky in windy conditions; having an assistant to hold the reflector can be useful.

## 139 Working alone

If you are working on your own, take a reflector with a built-in handle.

## Softening shadows using a reflector

### 140 Bouncing light

Lighting from a single source will inevitably create areas of shadow. If the contrast is too high, or the shadows look visually unappealing, you'll need to "bounce" some more light into the shadow areas to reduce contrast by lightening the shadows.

### 141 Vary the effect

Use a reflector to "push" a controlled amount of the main light back into the shadows. You can use the distance between the reflector and your subject to vary the intensity of the light reflected back into the shadows.

## Softening shadows using a diffuser

### 142 Disrupt light rays

A diffuser or translucent panel placed in the path of the light will disrupt strong light rays creating a softer, more flattering light.

# Softening shadows using fill-in flash

## 143 Fill-in flash

Use a small on-camera flash or the camera's built-in flash to fill in shadows. To look natural, the flash output must be set to deliver a lower light level than the ambient daylight.

## 144 Dedicated flash

With an auto flash function or TTL dedicated flash you can adjust the level of flash output via the camera.

## 145 Fool the flash

If you have a manual flash gun, the easiest way to obtain a natural fill-in effect is to fool the flash unit into thinking the ambient daylight is much brighter than it really is. You can achieve this by changing the flash gun's speed setting to a higher ISO, or by setting a larger f/stop than you are actually using on the camera. Both methods will cause the flash unit to reduce its output to avoid overexposing the shot.

## 146 Add sparkle

On an overcast day when the lighting is flat, there's very little you can do to increase contrast except to use some artificial light to add some sparkle. The harsh, direct light produced by a small on-camera flash unit could, for example, be used to create shadows or add highlights to a person's eyes.

## 147 Mimic the sun

Larger portable flash units designed to be used on location offer more flexibility, and if they're powerful enough, can be used as the main light to mimic the effects of the sun. In this case, the softer ambient daylight will provide the fill-in.

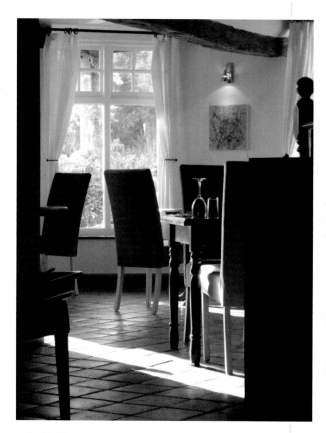

## 148 Mixed lighting

When your subject is lit by more than one light source, for example daylight and tungsten lighting, there are likely to be variations in intensity and color balance.

## 149 Measuring for mixed lighting

In mixed lighting situations, all of the light sources should be measured separately using the appropriate light meter; you can then choose which of the light sources will dominate the exposure.

# Artificial Lighting

## Portable Flash

Probably the most universal form of artificial lighting is provided by on-camera or battery powered flash guns. Generally, on-board flash is powered by the camera's main batteries and so offers a fairly low level of light output; separate battery powered flash guns offer a more powerful flash option. In this section we'll look at the equipment, the limitations, and the drawbacks of portable flash guns.

### 150 On-camera Flash

Almost every camera has an onboard built-in flash. While this sort of flash is fine for general snapshot photography, its light output is usually quite low.

### 151 Forcing the flash to fire

Onboard flash units can be set to either auto mode, where the camera decides if any extra light is necessary to avoid camera shake, or forced mode, when the flash will always fire. Using forced flash mode will result in the flash firing in situations where it simply can't illuminate your subject, such as when shooting landscapes. Also, unnecessary flashes drain the camera's battery.

### 152 Best of both worlds

Some compact cameras can be set to capture two shots every time the shutter button is pressed; one with flash and the other without. The camera records and displays both pictures giving you the choice between the effect of natural and flash light.

## 153 Hotshoe mounts

If your camera has a "hotshoe," you can mount a more powerful self-contained flash unit that will fire when you press the camera's shutter button.

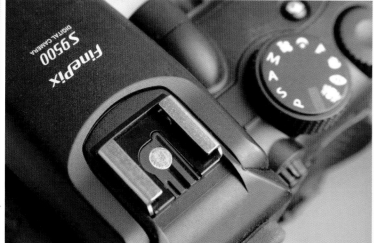

## 154 Single contact hotshoes

A basic hotshoe has one electrical contact which acts like a switch to simply trigger a flash. With a fully charged flash gun mounted in the hotshoe, pressing the camera's shutter button trips your shutter and closes the flash contact to fire the flash.

## 155 Multi contact hotshoes

If your camera offers sophisticated auto flash functions, the hotshoe will have more than one electrical contact so it can communicate with a fully-dedicated flash gun (see tip 158). Even if you don't have a fully-dedicated flash gun, the hotshoe will still work with a basic single contact flash gun.

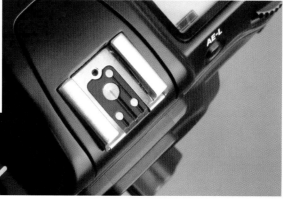

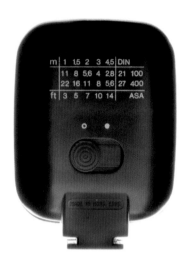

## 156 Basic flash guns

A basic battery flash gun is inexpensive and delivers a fixed light output. The unit has a simple table printed on its back showing the appropriate f/stop for a range of subject-to-camera distances, quoted at both ISO 100 for bright lighting conditions and ISO 400 for lower light levels.

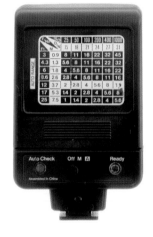

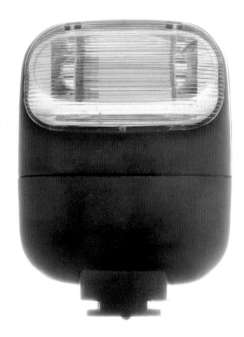

## 157 Auto options

The next step up from a manual-only flash gun is one that offers a basic auto function in addition to basic manual settings. The flash gun has a sensor which can detect the brightness of the light on the subject so it can deliver more or less light as required. The f/stop settings available for this basic auto function are printed on the back of the unit along with a distance guide for its manual settings.

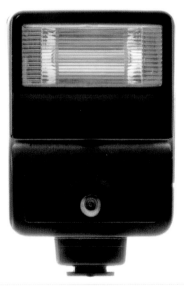

# 158 Fully-dedicated flash

If you buy a flash gun that is fully dedicated to your camera, the camera and flash can communicate with each other about exposure levels. This can be useful when grabbing shots in certain shooting situations but for total exposure control when using flash it's better to use manual.

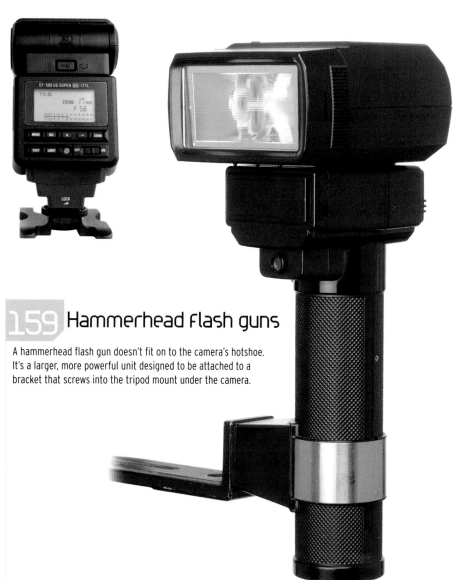

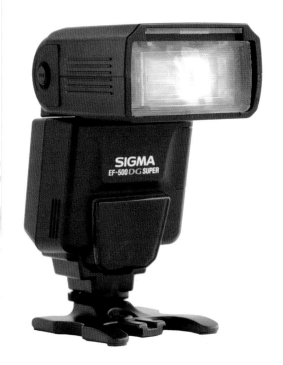

# 159 Hammerhead flash guns

A hammerhead flash gun doesn't fit on to the camera's hotshoe. It's a larger, more powerful unit designed to be attached to a bracket that screws into the tripod mount under the camera.

## 160 Flash coverage

A hammerhead's flash reflector is generally larger than standard hotshoe models, offering a bigger spread of light. This is useful when you need to take group shots at weddings, for example.

## 161 Guide numbers

All flash guns, whether battery or mains powered, have a Guide Number (GN). The Guide Number is a good indication of the unit's power output at ISO 100 over a fixed distance. For example, a guide number quoted as 28 or 28m would indicate that at ISO 100, the light would illuminate a subject up to 85ft (28m) away.

## 162 Technical: guide numbers explained

The formula for calculating exposure using the guide number is: f/stop = GN / distance. This formula is now commonly used as a buyer's guide when comparing different flash guns.

## 164 Zoom flash

If you're using a long focal length lens or zoom lens, your subject is likely to be some distance away from the camera, and perhaps beyond the range of a standard flash gun. Some flash units therefore have a detachable Fresnel lens that focuses the light over a narrower but longer range.

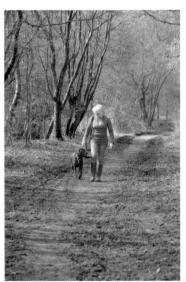

## 163 Flash coverage

A flash gun's fixed reflector spreads light over a fixed area. Depending on the lens you are using, the flash's angle of coverage may not be enough to light the whole scene. Wide-angle lenses need a wide angle of flash coverage, so some flash guns are supplied with a detachable lens to spread the light over a wider area.

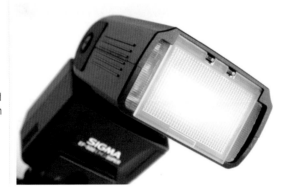

## 165 Standard settings

Cameras with built-in flash generally offer basic programmed flash modes allowing the user to force the flash on or off, as well as red-eye reduction (see tip 171) and slow sync flash.

## 166 Slow sync flash

In low-light conditions, the flash will only illuminate the subject correctly. The background will be underexposed and appear too dark in the picture. Slow sync flash mode allows you to use the flash with slow shutter speeds to capture more ambient light to lighten the background.

## 167 Next generation flash

The latest generation of flash guns are designed to be used on and off the camera either singly or in multiflash setups. These "intelligent" flash guns can be set as either a "master" or "slave" unit and their light outputs controlled from the camera position.

## 168 Limitations of flash

Although on-camera flash is useful for filling in shadows or grabbing shots in low-light conditions, the light produced is very harsh and direct. Shots lit by on-camera flash tend to look unnatural and unflattering with very defined shadows.

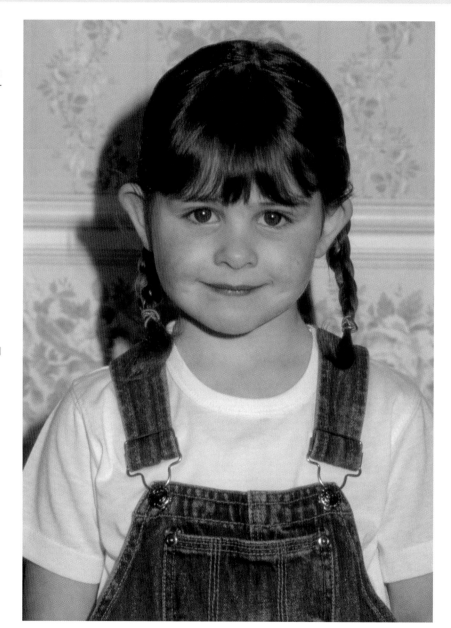

## 169 Red eye

A common side effect of direct on-camera flash is red eye. This is caused when the burst of flash is reflected back toward the camera by the eye's retina, giving the eye an eerie red glow like a cat's eyes caught in a car headlight.

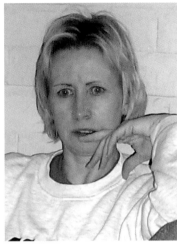

## 170 What causes red eye?

Red eye is most common when a flash is positioned very close to the camera's lens; such as on a compact camera or when a flash gun is mounted centrally on top of the camera body.

## 171 Red eye reduction programs

Red eye reduction programs work by firing a burst of flash at the subject to slightly dilate the pupils of their eyes, before firing another flash a second or so later to take the picture. Although this can be effective, it makes it difficult to take spontaneous shots as the time it takes for the double flash makes it virtually impossible to "capture the moment."

## 172 Light from the side

Mounting the flash on a side bar creates less of a problem with red eye, as the angle of the light is not directly into the subject's eyes.

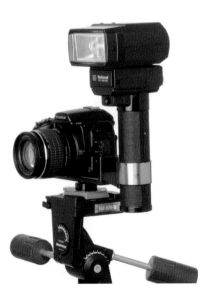

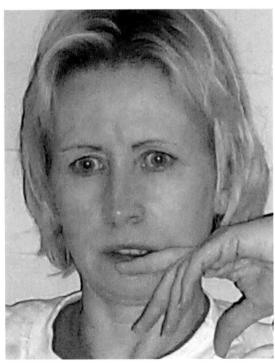

## 173 Improving flash quality

Whatever the subject, softening the flash makes the light more flattering and reduces red eye. You can soften flash light by diffusion or reflection.

## 174 Handmade softener 1

Try softening your on-camera flash by using opaque sticky tape over it to disrupt the light rays; making them much less direct and harsh.

## 175 Handmade softener 2

Another method is to tape layers of tissue paper over the front of the flash to diffuse the light. The thicker the tissue, the softer the light.

## 176 Refine your softener

Using either tape or tissue, the best results are obtained by curving the diffusion material slightly so it does not lay flat across the flash's reflector.

## 177 Purpose-made softener

If you have a fairly powerful removable flash gun, you can use an opaque plastic diffuser that will soften the light and reduce both glare and specula reflections.

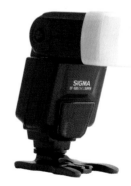

## 178 Portable softbox

Purpose-made softboxes are available that attach over the front of a portable flash. They are generally collapsible which makes them easy to carry in a camera bag.

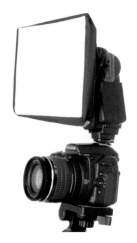

## 180 Tilt the hotshoe

If your flash gun doesn't have a bounce head, you can purchase a tilting accessory shoe that fits into your camera's hotshoe allowing a flash gun to be tilted.

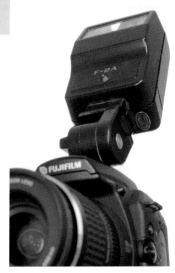

## 179 Bounce head

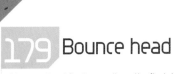

A bounce head flash gun allows the flash to be pointed upward at various angles so that its light can be softened by reflecting it from a ceiling.

## 181 Twist and bounce

Some bounce heads can also be rotated to allow the flash to be bounced from a wall or reflective surface.

## 182 Off-camera flash

Taking the flash off the camera adds another dimension to the lighting possibilities of battery flash guns by allowing you to position the light exactly where you want it.

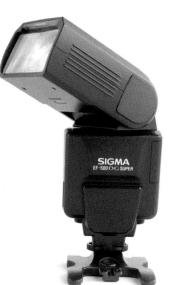

## 183 Accessory hot shoes

An inexpensive accessory shoe allows you to attach your flash gun to a tripod and provides the option to fire the flash into a brolly reflector (see tip 231) to soften the light.

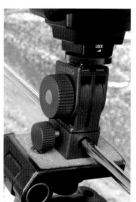
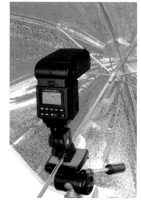

## 185 Slave cells

A "slave" is basically a light sensitive switch with its own hotshoe. If you attach a slave to a flash gun, it will trigger the flash when it detects a burst of bright light. This means when using a small flash gun or your camera's built-in flash, pressing the shutter button will fire the on-camera flash and trigger the slave cell on the brolly flash.

## 186 Ring flash

A ring flash power pack fits into the camera's hotshoe like a standard flash gun. However, unlike a standard flash gun, the ring flash unit fits directly on to the front of a camera's lens.

## 187 Softening the light

The ring flash has a diffuser with two flash tubes located on opposite sides of the lens. The mount can be rotated to provide left/right or top/bottom lighting.

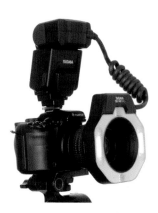

## 184 Remote flash

If your flash gun has no facility to fire it remotely, you will need a way to trigger the brolly flash from your camera. The simplest method is to use a second flash mounted on your camera to trigger the remote flash using an accessory slave cell.

## 188 Lighting preview

Some ring flash models also have modeling lamps fitted so that you can see the effects of the lighting before taking the shot.

## 189 Shadowless

The light produced by a ring flash is
virtually shadowless and designed
primarily for close-up photography
using macro lenses.

## 190 Extra power

When you're working on location, you will often require more power
than can be provided by on-camera battery flash units. The
alternative is a rechargeable power pack system.

## 191 Portable power pack

Usually consisting of one or two flash heads which attach to a
separate rechargeable powerpack, a portable flash system can offer
the same sort of light output as studio flash units.

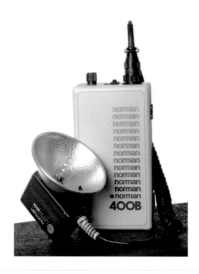

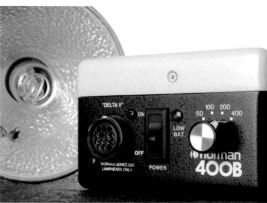

# Continuous light

## 192 Continuous light sources

Virtually any artificial light source will provide illumination for a photograph as long as it's bright enough. A light source that remains on all the time (as opposed to flashing on and off) is referred to as being a continuous light source.

## 193 Tungsten lamps

With a camera capable of a high ISO speed setting, household lamps are bright enough for photography, however it's worth pointing out that domestic lamps usually hang from a ceiling and therefore do not provide the most flattering light for portraits.

## 194 Reading lamps

Used in conjunction with an adjustable light fitting such as a reading lamp, a domestic lamp provides a versatile solution, but some domestic light fittings specify a maximum lamp wattage to prevent them overheating. You can use a reading light fitted with a 100 watt lamp for tabletop photography, but probably not for portraiture.

## 195 Tungsten light and white balance

Tungsten light has a warm orange color temperature so you need to adjust the camera's white balance if you're using domestic lamps.

## 196 Energy-saving lamps

If you're using energy-saving fluorescent lamps, which are not usually as bright as tungsten lamps, the camera's white balance needs to compensate for their green color balance.

## 197 Purpose-made lights

There are numerous purpose-made continuous lighting products available. In the main, they are less expensive than flash lighting but can still be fitted with a range of light-modifying accessories to soften or direct their light.

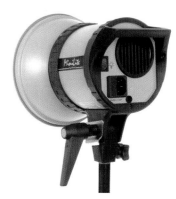

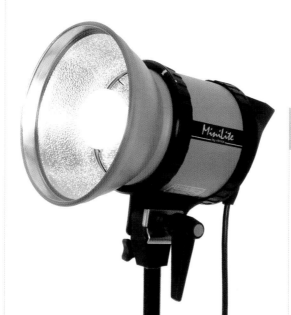

## 198 Lighting kits

Purpose-made photographic lamps are often sold in kits containing everything you need to get started, including stands, light-modifying accessories, and a carry case. Before buying this type of equipment, it's important to check the light output, as some models use extremely low-powered lamps that are not suited to portrait photography.

# Studio flash

## 199 Studio flash units

Sometimes called a "strobe," a studio flash unit will deliver an instant burst of "daylight" pretty much when and where you need it.

## 200 Light quality

The quality of the light produced by a studio flash unit is pretty much the same as the light from a battery powered on-camera flash gun. However the studio unit is capable of delivering much higher levels of light output.

## 201 Flash duration

The time it takes for a flash of light to start, reach full power and die away is called the "flash duration." If you imagine a curve starting at zero, rising to a peak and then dropping away to zero again, at different points along the curve the color temperature of the light varies from red to blue. Equipment manufacturers try to design studio flash units with very short flash durations so that the light produced is not biased to any particular color.

## 202 Recharging the flash

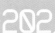

Mains power offers high levels of light output and fast recycling times. Most studio flash units are mains powered but portable varieties designed for use on location offer an extremely versatile alternative within the limitations of their battery capacity (see tip 190).

## 203 Power output

The power of flash output is measured in joules (j) and typically a flash head might be described as being a 250 joule or a 600j unit. Manufacturers normally incorporate a unit's output into its name, for example a Style 300.

## 204 High power

Higher powered professional units are often referred to in kilojoules (kJ), commonly a device capable of handling an output of 3,000j might be described as a 3kJ unit. There are two distinct types of studio flash unit: monobloc and power pack.

## 205 Monobloc

A very portable, self-contained, mains-powered unit which has its own onboard capacitors for storing the electrical charge that fires the flash. Typical output levels would be 250j to 1,500j.

## 206 Power pack

A separate control unit containing the capacitors and output controls that can be connected to one or more flash heads.

## 207 Power vs portability

A power pack system is much less portable than monobloc units but is capable of delivering a much higher flash output, typically 3,000 or 6,000j. This sort of power is really only necessary in professional studios.

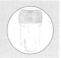

# Anatomy of a basic flash head

## 208 The flash tube

The flash tube is a glass tube filled with gas, usually xenon. Inside the flash unit, electrical current is stored in a capacitor which, when it's passed through the gas, causes a bright flash.

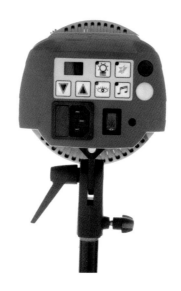

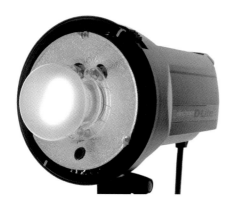

## 210 Mains power on/off

The capacitors used to store the electrical charge that fires the flash can hold their charge for some time after the power has been switched off. It's important to read the manufacturer's safety instructions fully.

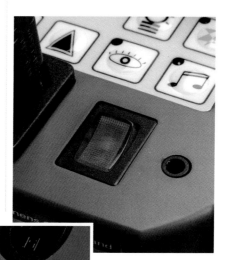

## 209 Modeling lamps

Because flash fires so fast, it's impossible to see the effect of the lights when setting up a shot lit by flash. Studio flash heads therefore all have a "modeling lamp;" a tungsten or halogen lamp that provides a low-power, continuous light, located very close to the flash tube. A modeling lamp is extremely useful as it gives an accurate preview of what the lighting will look like when the flash is fired.

## 211 Slave cell

When switched on, a built-in infrared/light sensor will trigger the flash when it detects a burst of light or infrared from another flash unit or from an infrared triggering device (see tip 228).

## 212 Slave cell on/off

If you are using more than one light, it can be useful to switch a slave cell off to stop the light from firing while taking a light meter reading from another flash head.

## 213 Flash ready beep

If you switch the "Ready Beep" on, the flash unit will provide you with an audible indication that the flash is charged and ready to fire.

## 214 Modeling lamp on/off/full power/ minimum power

You can vary the brightness of the modeling lamp to suit different shooting situations. Perhaps you might reduce its brightness if your subject finds the light too bright or increase its brightness when there's a lot of ambient light in your shooting area. It's usual to have options like on or off and full or proportional power. If you're using several lights, it's a good idea to use the proportional setting so you can see the overall lighting effect you'll get when all the flashes fire.

## 215 Flash output level

You can increase or decrease the flash output level using the unit's digital display to indicate the level of flash output over a 5 f/stop range.

## 216 Fine-tuning

The Up and Down buttons will adjust the flash output in increments of 1/10 f/stops. This is really useful when you are trying to balance the relative brightness or for fine-tuning the individual effects of several lights.

## 217 Flash ready/test button

This button lights up when the flash is charged and ready to fire. The button also fires the flash for test purposes or to register a flash meter reading without using a triggering device.

## 218 Sync cable connection

Designs and connectors vary but there will be a socket to attach a sync cable to the unit (see tip 222).

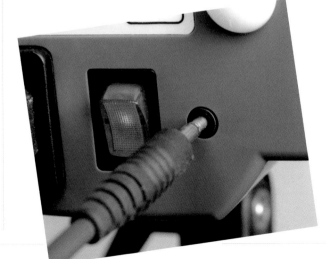

# Triggering the flash

### 219 Synchronizing camera and flash

Depending on your choice of subject, when you're shooting in continuous light (see tip 192), the most common shutter speeds you're likely to use are somewhere between 1/30 and 1/1000 second (see tips 028 and 029). Depending on the flash head you're using, a typical burst of flash lasts somewhere between 1/1200 second and 1/2000 second. This means the flash and the camera need to be synchronized so that the flash will only fire when your camera's shutter has fully opened.

### 220 Sync speed

In the same way as using on-camera flash, if your camera has manual exposure there will be a range of shutter speeds that can be synchronized with flash. Virtually all cameras will "sync" at 1/60 second; the full range of speeds will be detailed in the manufacturer's handbook that came with your camera.

### 221 Connect your camera

Once you have set the camera to the correct sync speed, you need to be able to tell the camera when you've pressed the shutter button. You can either do this by connecting the camera and flash directly together, or by remote control.

If you do not synchronize your shutter and flash, you will photograph the shutter as it moves across the image sensor.

## 222 PC socket

Many cameras are fitted with a PC sync socket, which allows a flash unit and camera to be connected together using a sync cable. Sync cables vary slightly in design and quality; however the camera connection is always a PC connector. The flash unit connector will vary from manufacturer to manufacturer.

## 223 Hotshoe adapter

If your camera doesn't have a PC socket, you can use a "hotshoe" adapter available from photography stores. The adapter fits into the camera's hotshoe, providing you with a PC connector.

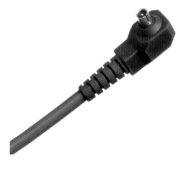

## 224 Firing the flash

When camera and flash unit are connected together by a sync cable, pressing the camera's shutter button causes a switch to close inside the camera, allowing a trigger voltage to pass down the sync cable and fire the flash.

## 225 Trigger voltage

If you are contemplating buying preowned flash equipment, it's worth checking the trigger voltage before making a purchase. Older lights intended for use with film cameras used high voltages that could potentially damage a digital camera. Around five volts is safe for most digital cameras, but check your camera's handbook to confirm the exact safe voltage.

## 226 Cable considerations

Using a sync cable is the most basic method of triggering a flash, but there are pros and cons to using a sync cable. They're relatively inexpensive and simple to use, but having a cable hanging between your camera and a flash unit positioned maybe 3-4ft (0.9-1.2m) away from you is clumsy and presents a trip hazard. There are alternatives that can trigger a flash remotely.

# 227 Camera flash

You can use a low powered on-camera flash gun to trigger the mains powered flash unit. As the output from the small flash is so low, it will not have any effect on exposure, but its flash will be bright enough to fire the mains powered unit's slave cell.

# 228 Infrared trigger

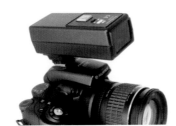

Alternatively, you can use a hotshoe-mounted infrared trigger. The slave cells built-in to most modern flash heads are sensitive to both visible light and infrared and will trigger the flash when they detect an infrared beam.

# 229 Multi channel

Some remote infrared systems feature a choice of infrared channels, allowing several photographers to work simultaneously without triggering each other's flash equipment.

# 230 Radio triggers

Radio triggering devices use a radio transmitter unit fitted to the camera's hotshoe with a receiver attached to the flash unit.

# Controlling the light

On its own, lighting equipment can only provide a convenient source of light. To control the quality of the light on a subject, you will need a selection of light-modifying accessories.

# 231 Brolly reflector

An umbrella or "brolly" reflector is collapsible and has a highly reflective fabric covering its inside surface. The lighting unit is directed away from the subject, and the stem of the brolly attached so that the light fills the inside of the brolly, reflecting it back toward the subject.

## 232 Avoiding spill

When using a brolly, it's always a good idea to use a spill kill (see tip 237) to direct all of the light's output into the brolly.

## 233 White brolly

A white brolly provides a soft, neutral light quality. Some white brollies are reversible, offering a choice of white/silver, white/gold, or white/black surfaces.

## 234 Silver brolly

A silver brolly reflects a crisper quality of light than a white brolly. Fashion photographers often use this harsh silver reflection for creative effect.

## 235 Gold brolly

A gold brolly reflects a warm glow on to the subject and is useful for warming up a subject's skin tone, giving it a more tanned appearance.

## 236 Diffuse brolly

A diffuse or "shoot-through" brolly is made of translucent fabric and is used in front of a light to soften its output by diffusion.

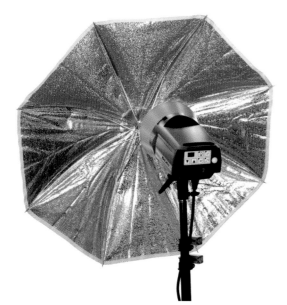

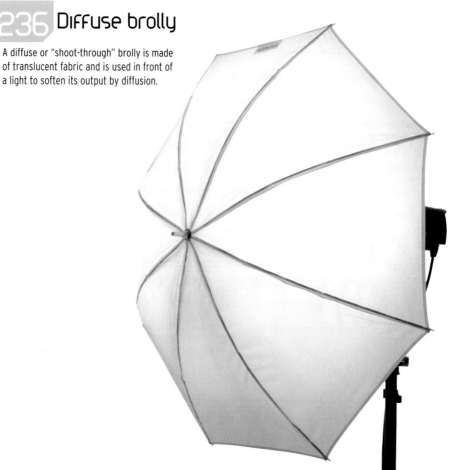

## 237 Spill kill

Some lights are supplied with a detachable wide-angle reflector to channel all of the light's output forward, preventing it from spilling behind the light. Some spill kills also have a bracket for attaching a brolly to the light.

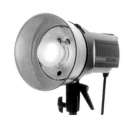

## 238 Snoots

A snoot is a cone-shaped tube that restricts the spread of light over a small area. This is useful for preventing a hair light spilling over on to a subject's face or creating a background lighting effect. Although the light is restricted to a small circle, its rays are not focused.

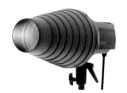

## 239 Dish reflector

A dish reflector is a highly polished metal reflector that spreads the light at a fixed angle. Some dish reflectors can intensify a light's output by as much as 1 f/stop.

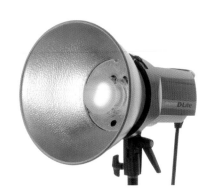

## 240 Barn doors

Barn doors consist of either two or four metal flaps that can be fitted to a dish reflector to restrict the spread of the light. Some barn door sets also have a facility for holding lighting gels (see tip 247).

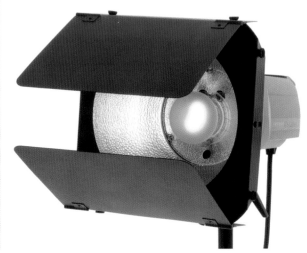

## 241 Softboxes

Softboxes are arguably the most popular method of softening a light's output by diffusion. Softboxes used to be heavy, rigid structures with opaque acrylic front panels to diffuse the light. However, today's softbox is highly efficient, lightweight, and collapsible for easy storage and transportation.

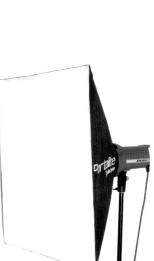

## 242 Softbox construction

The softbox itself is pretty much light-tight to prevent any loss of light output. The inside surface is silver on all sides to scatter the light before it leaves via the translucent front panel. The quality of lighting produced is soft and virtually shadowless. To soften the light even more, some softboxes have a removable second, internal diffusion panel, although this cuts down light output.

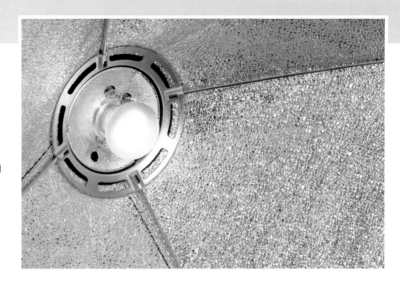

## 243 Collapsible

The exact design of softboxes differs from manufacturer to manufacturer, however the basic collapsible design usually employs a lightweight metal back-ring with a soft fabric covering. Internal metal or fiberglass rods are attached to the metal ring bracing the fabric cover to retain its rigid tent-like structure.

## 244 Size matters

The larger the softbox, the softer the quality of its light. Around 3ft square (0.9m²) is standard, but softboxes can be smaller or larger depending on the quality of lighting and subject coverage you require.

## 245 Striplights

This is either a long thin flash tube or a long narrow softbox which you can use for lighting a long narrow area.

## 246 Honeycomb grids

Honeycomb grids can be fitted over a metal dish reflector to restrict or direct the light over a fixed area. A typical set of grids will include both narrow and wide-angle attachments.

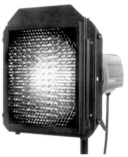

## 247 Gels

Gels are colored filters fitted over a light to correct or creatively color the light. A blue gel fitted over a tungsten lamp makes the color temperature closer to daylight.

## 248 Focusing spots

A focusing spotlight can either be a self-contained unit or an attachment for use with a monobloc flash head. The light has a Fresnel lens that can focus the light into a sharply defined beam or defocus for a softer edge to the light.

## 249 Focus the light

Focusing spots are often used by advertising photographers who want to contain a sharp beam of light into a very small area, or more commonly, they're used to project a pattern of light onto a subject or backdrop.

## 250 Gobos

The metal masks used with a focusing spot are known as gobos. They are like stencils through which the light can be focused to project the shadow of a window or blind into a lighting setup.

## 251 Flags

A flag can be pretty much anything used to block the passage of light. It could be a small piece of card or a 6ft (1.8m) piece of polyboard. It is best to paint flags black to prevent any unwanted reflections. You can use them to prevent unwanted light spill in a lighting setup.

## 252 Light panels

Light panels are large collapsible frames made of lightweight aluminum or rigid plastic that can be fitted with translucent fabric to make diffusion panels or reflective fabric to make reflectors.

## 253 Light stands

Like tripods, photographic lighting stands provide a firm support on which to mount your lights. All photographic lights attach to stands using a standard spigot fitting.

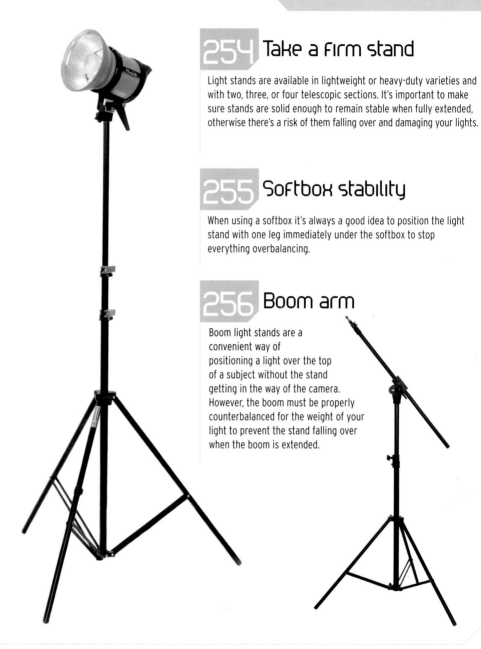

## 254 Take a firm stand

Light stands are available in lightweight or heavy-duty varieties and with two, three, or four telescopic sections. It's important to make sure stands are solid enough to remain stable when fully extended, otherwise there's a risk of them falling over and damaging your lights.

## 255 Softbox stability

When using a softbox it's always a good idea to position the light stand with one leg immediately under the softbox to stop everything overbalancing.

## 256 Boom arm

Boom light stands are a convenient way of positioning a light over the top of a subject without the stand getting in the way of the camera. However, the boom must be properly counterbalanced for the weight of your light to prevent the stand falling over when the boom is extended.

# Measuring artificial light

## 257 Choosing a light meter

To set the correct combination of aperture and shutter speed you will need to be able to measure the brightness of the light. If you are using a continuous light source, you need a standard incident light meter. For flash you need a flash meter, which is basically an incident meter for measuring electronic flash.

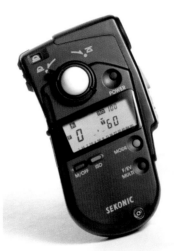

## 258 Buying a light meter

Many light meters offer the option to measure daylight, flash, and in some cases, a combination of the two. For those working within a tight budget, flash-only meters are available.

## 259 Flash meters

A flash meter is essential when working with flash lighting. If you have more than one light you can take accurate measurements of the light output from each flash head. Working with each light in turn enables you to build up a mental picture of which lights are the brightest and whether any adjustment to their output is required.

## 260 Taking a reading

A flash meter works in exactly the same way as an ambient daylight incident meter (see tip 077). The meter is held at the subject position and pointed toward the camera. The flash is then fired by means of a sync cable, or remotely using a triggering device (see tip 228).

## 261 Spot metering

If you intend to do a lot of tabletop photography, a flash spot metering facility is very useful for measuring small highlight or shadow areas on the subject; particularly if they're smaller than the meter's Invercone, or are in an inaccessible place.

## 262 Combination readings

A meter that can analyze a combination of ambient light and flash is useful for balancing flash with daylight or mixing flash with tungsten light.

## 263 Multi popping

If you're shooting tabletop subjects, you will sometimes need to use a small aperture, for instance, where maximum depth of field is important (see tip 046). If this is the case, but the output of your flash is not powerful enough, it's possible to build up the level of brightness by firing the flash several times; this technique is known as "multi popping." To do this, you'll need a flash meter that can measure the effect of multiple flashes.

## 264 More multi pops

Multi popping requires a darkened shooting area to prevent ambient light influencing the exposure. Using a very slow shutter speed, the flash is triggered manually a number of times while the camera's shutter is open. Try not to jog the camera or you'll blur the picture.

# How many lights do you need?

## 265 One light is often enough

Whether it is continuous or flash, provided a light supplies enough output, there's a lot you can do with just one light. Many of the lighting projects in Section 5 are achieved using only one light.

## 266 A basic portrait kit

If you want to try basic portraiture, you don't need to invest in lots of lighting equipment to start with. You can use a small, battery-powered flash gun mounted off-camera in a hotshoe bracket. As the flash light will be too harsh for natural-looking portrait lighting use a silver brolly attached to the hotshoe bracket and you'll have an inexpensive portrait starter kit.

## 267 Efficient working

Professional photographers have a large number of lights at their disposal, but this probably has more to do with efficiency and flexibility than creativity or necessity. It's worth remembering that possessing a lot of lights is not the same as using a lot of lights, what *is* important is the positioning of the lighting and quality of the light it produces in the picture.

## 268 The subject-to-camera axis

If you imagine a straight line drawn from your subject straight to your camera's lens, this line is called the "subject-to-camera axis." A large number of subjects can be very successfully photographed by positioning one light to the left or right of the camera at an angle of about 45 degrees to that line.

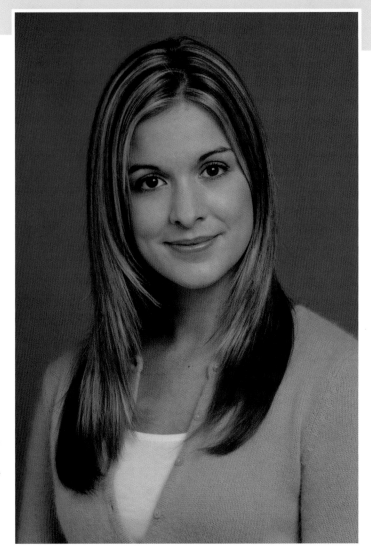

## 269 Experiment with the light's position

Provided you keep the distance between your light and the subject the same (to maintain the same exposure), you can vary the angle of the light around the subject-camera axis to produce dramatic lighting and shadow effects. The following tips illustrate this.

# Working with one light

### 270 90 degrees

When a single light fitted with a softbox is positioned at 90 degrees to the subject-to-camera axis it illuminates only half of the subject and the other half is in shadow.

### 271 45 degrees

Moving the light to about 45 degrees produces a more natural lighting, but there are still quite pronounced shadows.

### 272 Straight on

If the light is positioned very close to the camera, shadows are considerably reduced and the subject has a natural, three-dimensional feel to it.

## 273 Experiment with height

When a light is very close to the subject-to-camera axis and raised above the subject position, the lighting is both natural and flattering, but there is increased shadow under the subject's nose and chin.

## 274 Old master

The lighting produced when a light is positioned at 45 degrees to the subject-to-camera axis but behind the subject, produces the impression of light coming from a window, but creates shadow on the face. This type of lighting is a favorite with painters.

## 275 Add some Fill

A white polyboard reflector positioned to the left of the camera can be used to bounce some light back on to the subject to fill the shadows. This type of lighting is often used to create "character" portraits of male subjects.

## 276 Avoid unflattering shadows

In portraiture, one light on its own tends to create shadows on the face which most people find unflattering. Using a reflector to fill the shadows results in a more flattering portrait (see tip 340).

# Working with multiple lights

## 277 A second light adds more possibilities

A second light affords a much greater degree of flexibility in portraiture lighting. A reflector can lift shadows on the face, but the variable output from a second light positioned at about 45 degrees to the left of the camera, can be used to vary the amount of fill. With both lights set at equal output, shadows are almost indiscernible.

## 278 Try a hair light

A second light can be fitted with a snoot and used behind the subject to create a natural hair light effect.

## 279 Using three lights

Introducing a third light into the setup gives you all the flexibility of two frontal lights but with the option to use the third light for the subject's hair or for lighting the backdrop.

## 280 An extra dimension

Light coming from behind your subject or lighting the backdrop creates separation and adds a more three-dimensional feel to your portraits. If you're using a hair light you can adjust the output of the light to vary the effect from a bright glow to a more subtle, natural light (see tip 395).

# Purchasing lights for photography

Before purchasing photographic lights you need to decide whether you want continuous lighting or flash.

## 281 Subject checklist

If you're going to invest in some photographic lighting, the first question to ask yourself is, will the lights be used to photograph people or still-life subjects on a tabletop? The following tips will explain why this is important.

## 282 Cost

Continuous lighting is generally less expensive than flash, but the light output is usually much lower, unless you're looking at professional tungsten lighting, which is fairly expensive.

## 283 Camera compatibility

Any camera can be used with continuous lighting, but you will need manual exposure control if you want to use flash.

## 284 Is your subject likely to move?

Low-light output means you will be working with wider apertures, slower shutter speeds, or both, so if you're going to use low-powered lights for portraiture, your subject might have to sit very still. This was a problem faced by the early pioneers of photography in the nineteenth century; they often needed to clamp their subject's heads in position to stop them moving during a long exposure, which is probably why the people in old-fashioned portraits always look so miserable! On the other hand, low-power lighting is ideal for photographing still-life subjects that aren't going to move.

## 285 Keep your subject cool

Low-powered lights will naturally have to be positioned closer to the subject than more powerful ones, so it's worth thinking about their heat output and the effects this could have on your subjects.

## 286 Consider future upgrades

At some stage you will want to modify or control the light on your subject; to do this effectively you will need to purchase accessories to fit on to the lights. Accessory mounts are not standard from one manufacturer to another. Before you purchase any brand, however inexpensive, it's worth considering whether there is a good range of accessories available, either from the manufacturer or from third party suppliers. If you buy into a budget brand, it might be harder to upgrade your lighting equipment in the future. Look for a manufacturer that uses the same accessory mount for its complete range; from continuous lighting to budget flash and right through its professional models. In this way, any accessories you purchase will never be obsolete.

## 287 A studio in a box

Buying photographic lights is not just about the lights themselves. You will need lighting stands and a way to modify the quality of the light output; most usually a softbox or brolly. A ready made studio-in-a-bag kit can often contain everything you need to get started: stands, softboxes, and a light meter; you might also find a kit that includes a remote flash triggering device. Studio starter kits are usually more economical than purchasing all of the component parts separately, but check that the kit contains only the things you need.

# Lighting Setups

## Practical projects
Whether you're trying to photograph items to sell at online auction sites, perfect your portraiture, or pick up a few advanced lighting techniques used by the pros, this section provides you with a range of simple lighting setups to create stunning images with the minimum of equipment and technical knowledge.

## Project 1: copying artwork

### 288 Using a little know-how

If you want to sell artwork over the internet, keep a record of a painting for insurance purposes, or just e-mail a copy of a print to a friend, you will need to photograph it. Pointing your camera at a painting and pressing the shutter button will make an adequate record, but if you want your picture to look as good as it does in real life, you need to use a little lighting know-how.

### 289 Keep it flat

To photograph flat artwork, such as paintings or pages from glossy magazines, you need an even exposure across the entire image area and this requires very flat lighting.

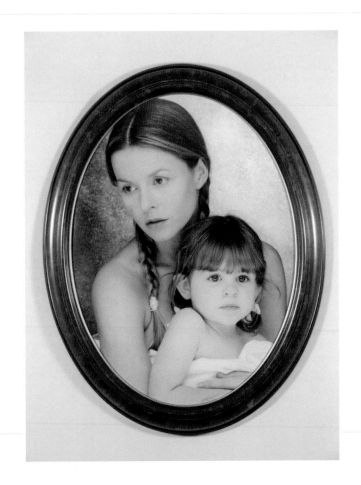

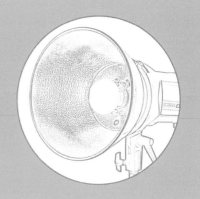

## 290 | Copyright issues

If the artwork is subject to copyright, it's important to make sure you have the copyright owner's permission to reproduce it.

## 291 | Keep it square

You can lay the artwork down flat on the floor, but it is preferable to hang it on a light-colored wall. Having the picture hanging squarely will make it easier to line up your shot in the viewfinder.

## 292 | Try a tripod

To avoid recomposing the shot each time you adjust the lighting, position the camera on a tripod about 4ft (1.2m) away from the artwork and adjust the zoom lens until it fills the viewfinder.

## 293 | Fill the frame

If the artwork is in a frame, you can choose whether or not to include the frame in your shot by zooming in and out. Remember that the frame won't be as flat as the artwork, so there's a good chance your lights will reflect in the frame, causing distracting highlights (see tip 296).

## 294 | Avoiding reflections

The shiny surfaces of glossy prints, magazine pages, and varnished paintings will reflect any lights you direct toward them, resulting in bright white highlight areas that will obscure the detail in your artwork. With a little technical know-how you can position your lights to eliminate any unwanted reflections; the following tip explains how.

## 295 | Technical: the angle of incidence

The angle of incidence is equal to the angle of reflectance. This rule simply means that if light hits a subject at a particular angle, it will be reflected at the same angle; you can use this rule to position your lights so they don't reflect straight back at your camera (see tip 297).

## 296 | Hard or soft?

With a flat subject the quality of the light is not important, you can use softboxes or basic dish reflectors on your lights—both will provide an even spread of light. However, the softer light produced by a softbox will help to subdue any reflections if your artwork is in a frame (see tip 293).

## 297 | Step 1

Position one light to the right of the camera at an angle of about 45 degrees. There will most likely be reflections of the light on the surface of the artwork.

### 298 Step 2

Adjust the light by moving it outward away from the camera position, until there is no reflection in the artwork when you look through the camera.

### 299 Add a second light

It is very difficult to achieve flat lighting using only one light. The lighting must be even across the entire image which means you need two lights. If the artwork is large, you might need four lights to get an even spread of light.

### 300 Step 3

Position a second light at the opposite side of the picture as a mirror image of the first light. Check there are no reflections on the artwork from the second light.

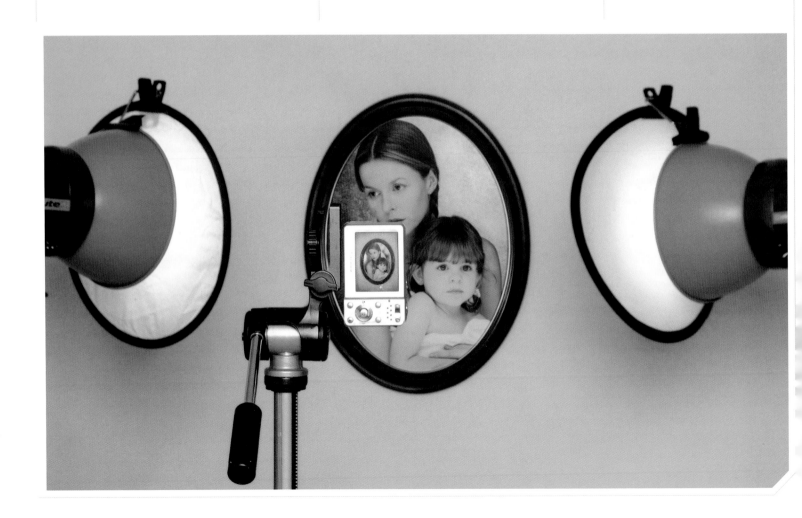

## 301 Step 4

If the artwork is in a frame, there is a good chance the lighting will reflect in the frame causing highlights. Using diffusers clamped to the front of the lights will soften and spread the highlights adding a three-dimensional feel to the shot. When using homemade diffusers in front of lights, it's important to make sure they're made of fireproof material.

## 302 Consider the shadows

A frame is almost certainly going to cause shadows either on the wall behind the artwork or around the edges of the image area. Diffuse light will soften these shadows.

## 303 Step 5

Use a light meter to check that there is an even spread of light across the entire artwork. Make sure any variations are within 1/3 f/stop and adjust the light output as necessary, or move the lights a fraction farther away.

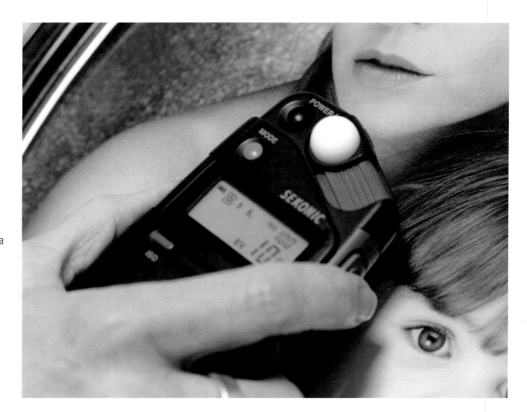

## 304 Bracket your exposure

The light meter's suggested exposure will be a good starting point. However, it is advisable to bracket your exposures and select the best shot when the pictures can be viewed on a larger screen than the camera's LCD preview.

# Project 2: collectible coffee mug

### 305 Better pictures mean easier sales

People who buy or sell items at online auction sites will know that a good product picture creates more interest than a poor one. Usually it's the lighting in a picture that makes the product look dull. The skill of professional advertising photographers is to create lighting effects that make even the most ordinary product look interesting and appealing. Getting the lighting right in a shot is easy and with just a little know-how, you can take clear, well-composed shots that will make your products look saleable.

### 306 How the camera "sees" the object

Place the object on a tabletop and look at it on the camera's viewfinder or display. Ask yourself, does the product look saleable? Does it blend into its surroundings? Are there specula reflections or distracting shadows? Try taking a couple of pictures both with and without your camera's flash.

### 307 Seamless backdrops

In advertising photography, products are often shot on a plain background to isolate them from their surroundings. A seamless backdrop is one that doesn't have an obvious horizon. Advertising photographers use rolls of colored paper as backdrops, but it's easy to create an inexpensive seamless backdrop using a sheet of artist's paper.

### 308 Step 1

To create a simple but effective product shot, position a table near a window with a good supply of daylight. Carefully curve the paper background and support the back with something suitable. It's not going to be in the shot so you can use anything heavy enough to support the paper; in this case it's a packet of breakfast cereal.

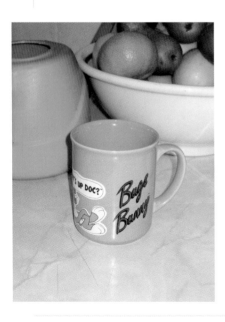

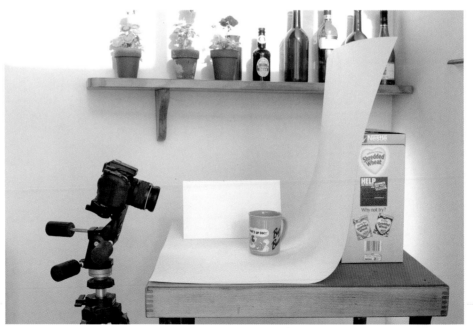

## 309 Step 2

Clamp the front edge of the paper to prevent it slipping off the table.

## 310 On-camera flash

You can try using on-camera flash but the likelihood is it will overpower your subject, washing out some of its color and creating specula highlights (see tip 107).

## 311 Soften the shadows

If you're shooting with direct sunlight there will be shadows which won't add much to the look of the shot. You can soften the shadows by diffusing the light.

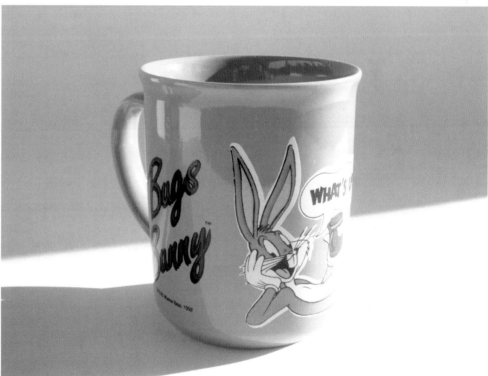

## 312 Diffuse the light

Try hanging a net curtain or white bed sheet over a large window to soften the lighting in the whole room.

## 313 Handmade diffuser

Alternatively, you can make a diffuser using a wooden or cardboard frame covered with tracing paper or translucent fabric. Position the diffuser near to your setup to soften the light on the product.

## 314 Add some fill-in

To even out the lighting across the product, use a piece of white cardboard or foam core board as a reflector. Position it out of shot to fill any remaining shadows.

## 315 Using flash

If there's no daylight available, you can use off-camera flash as long as there's a way to soften the light. You could bounce the flash off a large white wall or foam core board, or use a diffuser.

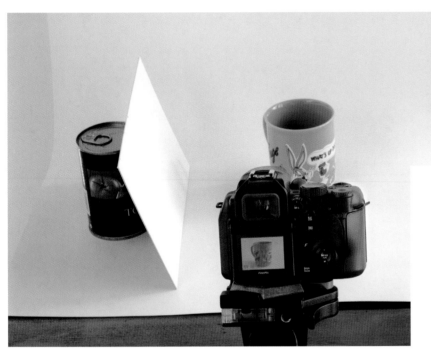

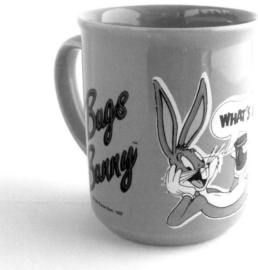

## 316 Using tungsten

As your subject is not going to move, you could use a domestic table lamp to light it. The light will need to be softened to avoid unwanted shadows on the backdrop. Positioning translucent material at a safe distance in front of the lamp will soften the light by scattering its rays but if it's too close to the lamp, the heat could present a fire risk.

## 318 Ease of use

Tabletop studios are usually supplied with a removable fabric backdrop and the whole thing is easily folded flat for convenient storage.

## 317 Tabletop studios

If you intend to take a lot of simple product shots, you should consider purchasing an inexpensive tabletop studio. This has three diffusion panels that create instant soft light whether you're working with daylight, tungsten lamps, or flash.

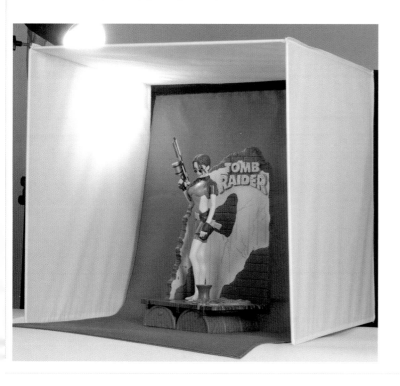

## 319 White balance

When using a tungsten light source, remember to set your camera's white balance to auto or set a custom white balance to avoid the picture appearing too orange.

# Project 3: creating a pure white backdrop

### 320 Working with white

You'll often see professional shots of products set against a pure white backdrop. Creating a white studio backdrop requires a few special lighting considerations, but once you know how it's done, working with white is easy.

### 321 Problems with shadows

If you position your subject just in front of a white backdrop, and your lights about 4ft (1.2m) in front of the subject, a light meter reading taken from the subject might, for example, indicate an exposure of 1/60 second at f/8. Although the subject will be correctly exposed using these settings, the subject's shadow will make the white background look muddy (see tip 177).

### 322 Avoiding shadows

Moving your subject away from the backdrop means there will be no shadow. If you move the subject 4ft (1.2m) away from the backdrop the shadow will be hardly visible.

### 323 Dark backgrounds

If you then reposition your lights as before, about 4ft (1.2m) in front of the subject and use the same exposure of 1/60 second at f/8, the subject will still be correctly exposed but the backdrop will be much too dark.

### 324 Double the distance needs four times the light

With an object 4ft (1.2m) away from the light and an exposure setting of 1/60 second at f/8, increasing the distance between the subject and the light to 8ft (2.4m) would require an increase in the light output of four times, or opening the aperture two f/stops to f/4. The following tips explain why.

### 325 Technical: the inverse square law

The inverse square law is a law of physics that has a real impact on photographic lighting. It states that if you use a point light source (such as a studio flash head) and double the distance between the subject and the light, the fall off of light is four times.

### 326 Light the backdrop separately

To make a background pure white, you will need to light the backdrop separately. This will require an even spread of light right across its area. Depending on the size of the backdrop, position either one or two lights on either side of the backdrop at about 45 degrees in much the same way as the lighting arrangement for copying a flat artwork (see Project 1).

### 327 Meter readings

Take a meter reading from various points around the entire backdrop area—variations of 1/3 of an f/stop are not significant, but try to keep the spread of light as even as possible to avoid "hot spots."

### 328 Hot spots

Hot spots are areas where the lighting is much brighter than the overall level of exposure that can reflect back toward the camera and cause flare in the lens.

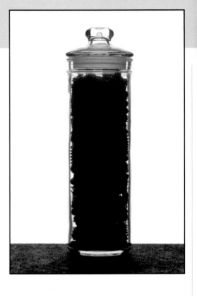

## 329 18 percent gray

Remember, a light meter will suggest exposure settings to record things as 18 percent gray, not white. To get a white background you will need to overexpose by increasing the light output +1 or +1 1/2 f/stops.

## 330 An alternative method

Alternatively, use some translucent material such as an opaque acrylic sheet or a translucent fabric diffuser as a backdrop, and position lights behind it, taking care they don't spill on to the main subject and cause it to overexpose.

## 331 Keep it white

Once you have a pure white backdrop you can concentrate on lighting the subject separately, but remember to keep the background lights brighter than the main exposure by around +1 f/stop.

## 332 Be aware of flare

It's worth checking that there is no light bouncing off the backdrop that will interfere with your main subject lighting or cause flare. Hold your light meter immediately behind the subject with its Invercone pointed at the backdrop and take a reading; if the reading is brighter than your main exposure, move the subject farther away from the backdrop or readjust the light output of the background lighting.

## 333 Filling in the detail

Light reflected by the white background creates a recognizable semi-silhouette of the pasta jar; if you want to make the contents of the jar visible, the technique is discussed fully in Project 5.

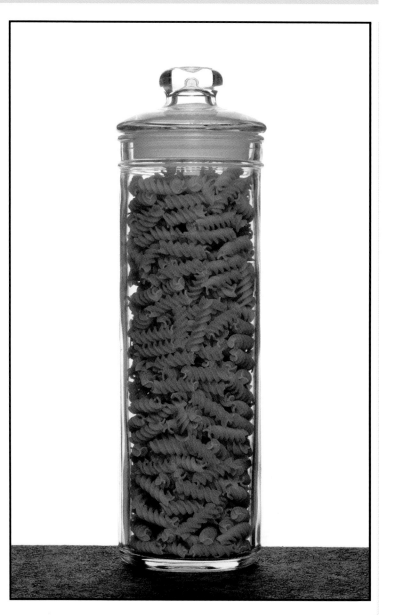

# Project 4: indoor portrait using one light

## 334 The setup

A single light fitted with a softbox has been set up on a stand to the right of the camera, at about 45 degrees to the subject.

## 335 Get the height right

The height of the light is adjusted so that it is slightly above the subject and angled downward to create an even lighting effect over the subject's head and shoulders.

## 336 Check the spread

You will need to check that the light is covering the whole of the subject if you plan to include more than just the head and shoulders in your portrait. The spread of light can be increased by using a larger softbox or moving the light farther away from the subject.

## 337 White balance

Remember to set your camera's white balance to daylight if you're using flash. For continuous light sources, you will need to use the appropriate setting.

## 338 Exposure

If you have manual control over your exposure, take a light meter reading with your meter's Invercone pointed toward the camera and set the aperture and shutter speed suggested by the meter. If you have a continuous light source, you can use an auto-only camera; set your camera to auto and turn off the built-in flash.

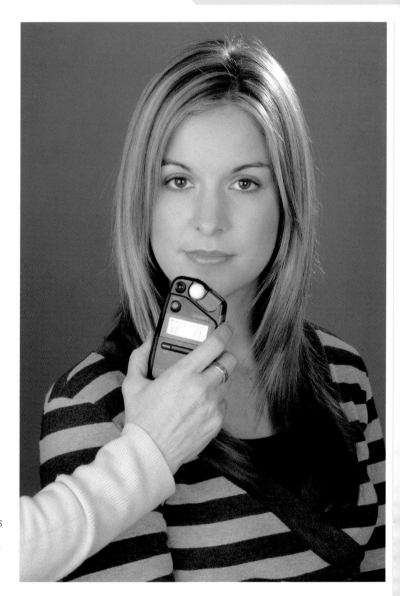

## 340 Fill in the shadows

If you position a silver reflector on a stand to the left of the camera position, you can bounce some light back onto the subject's face; this will soften the shadows and create a more flattering portrait.

## 339 Assess the result

The result is a pleasing, natural portrait, but the shadows on the right side of the subject's face are distracting and not particularly flattering.

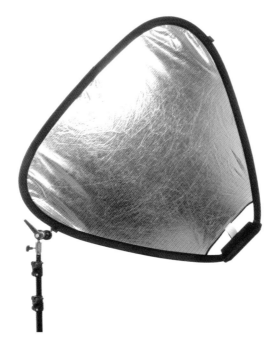

## 341 Vary the effect

As the reflector is only reflecting the light, its effect does not alter the exposure. The amount of fill-in can be controlled by varying the distance between the reflector and the subject.

# Project 5: glass against a white background

## 342 Use the right light

Glass is naturally shiny so to avoid distracting specula highlights (see tip 107) it's best to avoid using on-camera flash or tungsten room lamps to light glass objects.

## 343 Backlighting

Glass and translucent objects look best when lit from behind to show the color of the contents or the color of the glass.

## 344 Step 1

Place the bottle on a tabletop and set up your camera on a tripod or firm support. Check the camera's viewfinder or LCD display and compose the shot.

## 345 Step 2

Position a white backdrop some distance behind the table; the exact distance will be governed by the size of the backdrop. If it's a small sheet of paper, keep checking through the camera's viewfinder to make sure the backdrop is filling the whole picture area. If the backdrop ends up very close to the bottle, you'll need a bigger backdrop or the lights will reflect in the bottle.

## 346 Step 3

Set up two lights, one on either side of the background, as described in Project 3, creating a pure white backdrop.

## 347 Flash light

If you're using flash, take flash meter readings from around the backdrop to make sure it's evenly lit. Remember, the light meter will suggest an exposure to make the backdrop 18 percent gray, so you'll need to set the camera +1 f/stop to get a white backdrop.

## 348 Tungsten light

If you're using tungsten light, you can either use a separate light meter, or the one in your camera. However, both will suggest an exposure to make the backdrop 18 percent gray. If your camera allows you to set the exposure manually, set the aperture +1 f/stop. If your camera is fully automatic, use the exposure compensation menu to set +1 EV.

## 349 White balance

Set the camera to auto white balance if you're using continuous lighting or set it to daylight if you're using flash.

## 350 Exposure considerations

The depth of color of the glass will make a difference to the amount of light passing through it; pale glass will let more light through while dark glass will restrict the light. Take a test picture and check the camera's preview. Depending on the color of the glass you're using, you might want to increase the exposure by opening the aperture a little more to make the contents of the bottle look brighter.

## 351 Frontal lighting

As all the light is coming from behind the bottle, there's no light on the front of the bottle to illuminate the label, so it will appear too dark.

## 352 Step 4

To light the label, position a piece of white cardboard or foam core board on either side of the front of the bottle, just out of shot, to reflect some of the light back on to the label.

# Project 6: outdoor portrait

Rather than providing a step-by-step guide, this project looks at some of the lighting considerations you'll need to overcome to create natural-looking portraits outdoors in a variety of lighting conditions.

## 353 Natural hair light

To avoid any problems with the sun shining in your subject's eyes or with shadows on their face, position your subject with the sun behind them. This will act as a natural hair light and add some warm highlights to their hair.

## 354 Avoid flare

When shooting toward the sun, you need to make sure the light isn't shining directly into your camera's lens, creating unwanted flare.

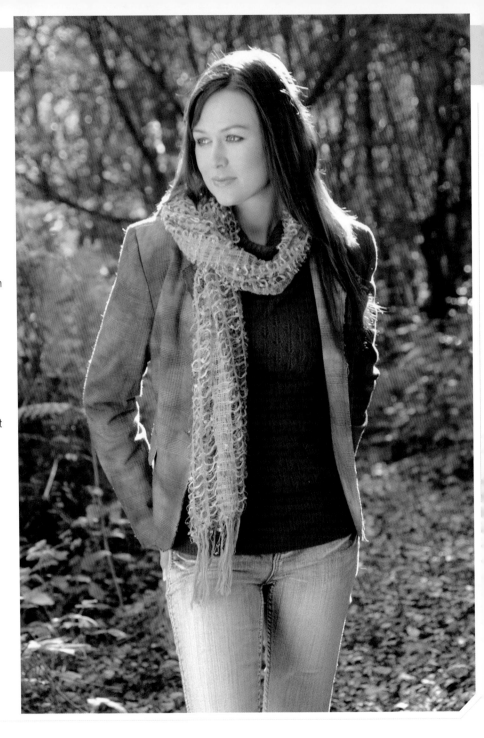

## 355 Lens hood

Some lenses are supplied with a removable lens hood that creates a shade around the front element of the lens, helping to prevent flare.

## 356 Improvised lens shades

If you don't have a lens hood, you can improvise by using your hand or a piece of card held just above the front of the lens. Remember to double-check that this is not visible in the shot.

## 357 Unwanted shadows

With your subject against the sun, their hair is going to be brightly lit, but with all the light hitting the back of your subject, their face will be in shadow.

## 358 Backlighting

This sort of backlighting will usually fool your camera's exposure metering system; it will want to set an exposure for the bright background, making the subject too dark (see tip 068).

## 359 AE Lock

Using the camera's TTL light metering system, you could take an exposure reading for the light reflected from the subject's face and use AE Lock to hold that setting. But as the light from behind the subject will be so much brighter than the light in front, the background will be too bright (see tip 127).

## 360 Meter for shadow and highlight

With its Invercone pointed toward the camera, use a hand-held light meter to take a reading of the light falling on the subject's face. Take a second reading with the meter behind their head pointed toward the sun. These two readings will provide a good indication of the contrast range between highlight and shadow detail.

## 361 Reduce contrast

To take a pleasing portrait in this type of shooting situation, you will need to reduce the contrast between highlight and shadow.

## 362 Use a light meter

You can use on-camera flash to brighten up the foreground, however direct flash like this can look very unnatural in portraits. For best results, use a hand-held light meter to measure the light all around the subject and set this as your exposure on the camera.

## 363 Fill-in flash

Using a manual flash gun, set the flash exposure to -1 f/stop less than the level you set on the camera. If your camera has an auto fill-in flash setting use this, but it's likely the flash will still be a little too bright.

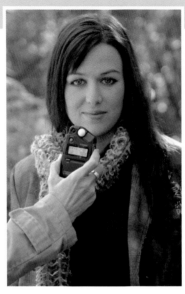

## 364 Take a test shot

Take a test shot and check the camera's LCD screen to make sure you're getting the effect you want; adjust the flash output if necessary.

## 365 Add fill-in flash

Take a tip from professional wedding photographers who use fill-in flash to add sparkle to a bride's eyes. To make the effect appear as natural as possible, they will often take a series of test pictures, systematically reducing the output of their flash until its effect is only just visible in the shot.

## 366 Reflectors are subtle

A more subtle alternative to using fill-in flash is to use a reflector to bounce some of the sun back toward the subject's face.

## 367 Keep lighting natural

In strong sunlight, the effects of a silver reflector can be quite harsh, making the lighting look unnatural. An added drawback is the bright reflection from the silver surface which can be uncomfortable on your subject's eyes.

## 368 White is right

A soft white reflector does not bounce quite as much light as a silver reflector, but the effect is more natural and the reflection will not make your subject squint.

## 369 If there's no sun

On a dull day a reflector will not be of much use to you. However, fill-in flash will add sparkle to the subject's face and a catchlight to their eyes.

## 370 Soften the flash

Using a softening device on the flash will provide the most flattering light from the flash.

# Project 7: jewelry

## 371 Contrasting textures

The fine, shiny detail of jewelry can be complimented by photographing it against a coarser texture. A paving slab bought from a local garden supplies store and painted black was used for this shot.

## 372 Step 1

Place the paving slab on a suitable tabletop, set your camera on a tripod, and compose the shot. Make sure the jewelry is in the center of the frame or your final picture will look off-center.

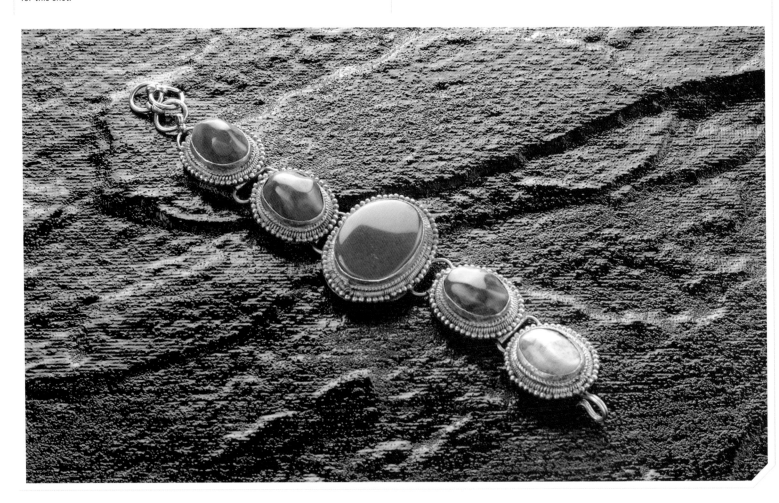

## 373 Step 2

To reveal the texture of the paving slab, position one light fitted with a softbox behind the setup. The light needs to be very slightly above and angled down toward the paving slab.

## 374 Step 3

The light needs to be high enough to light the bracelet, but low enough to skim the light across the slab without flooding it with light. Keep checking the camera's viewfinder until you can see the lighting effect you want.

## 375 Step 4

With all the light coming from the back, the front edge of the bracelet is in shadow. Placing two small pieces of mirrored card just out of the shot, to the left and right of the bracelet, will reflect some of the light from the softbox back on to the front and side edges of the bracelet.

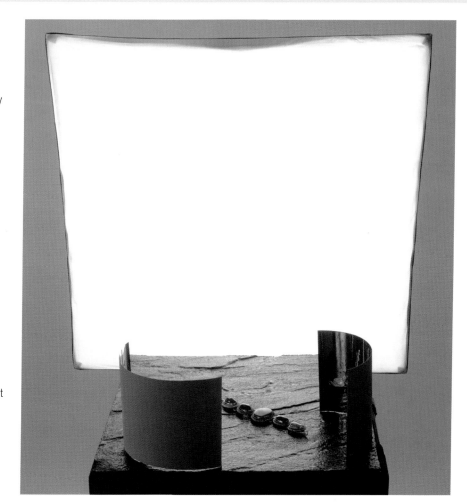

## 376 Step 5

As the light reflected in the paving slab will make it appear a shade of gray, the meter's suggested exposure setting will be a good starting point. Take a light meter reading from about the middle of the shot and shoot a test picture. Adjust the camera's aperture or EV setting as necessary to strike a balance between the bracelet's bright highlights and the texture of the paving slab.

# Project 8: glass against a dark backdrop

## 377 Dark backdrop

To reveal the contents of a bottle or translucent object set against a dark backdrop, you need a way of forcing some light through the glass from behind.

## 378 Step 1

Position the bottle on a suitable tabletop and set up the camera on a tripod to compose the shot.

## 379 Step 2

Any light positioned in front of the bottle will just create white highlights on the surface of the glass so it's more effective to light from the side. Position one light fitted with a softbox to the side of the bottle.

## 380 Step 3

Using a large light source like a softbox or translucent panel allows the light to pass in front and behind the bottle.

## 381 Step 4

Looking through the camera, you'll see a large white highlight along the side of the bottle. You can either leave this as it is, or use a piece of black card to restrict the amount of light hitting the bottle. In the shot here, black card was positioned in front of the light at about 45 degrees to the camera position, reducing the size of the highlight by making it narrower.

## 382 Step 5

If the backdrop is dark, it will not require any special lighting, unless for creative effect. To make sure the backdrop appears how you want it to, it's a good idea to check whether any of the light is spilling onto the backdrop and mask the light with black card as necessary.

## 383 Step 6

To push some light through the glass toward the camera, use a small piece of mirrored card cut roughly to the profile of the bottle. Angle it so that the light from the softbox is reflected through the glass and back toward the camera.

## 384 Step 7

To keep the mirror in position, use a piece of Blu Tak or plasticine. This will allow you to reposition the card as necessary to keep it out of the shot.

## 385 Step 8

Use a light meter to measure the light falling on to the bottle and make a test exposure.

## 386 Step 9

If you are using a continuous light source like tungsten, you will need to set the camera's white balance.

## 387 Step 10

Check the camera's LCD preview to see the effect of the lighting. Depending on the depth of the color of the glass or its contents, you might find that the light isn't bright enough to shine right through the glass. To increase the mirror's backlighting effect, you can increase the exposure beyond what the light meter suggests.

## 388 Step 11

The label on the bottle will almost certainly be too dark. Use a piece of white card in front of the bottle at about 45 degrees to the camera position to reflect some light toward the label.

## 389 Step 12

If there's any gold or silver lettering on the label, you will need to position another piece of card or a reflector to bounce some white light on to the lettering or it will appear dull in the final photograph.

## 390 Bracketing

It's always a good idea to bracket your exposures when shooting this type of setup. This will provide you with a range of lighting effects to choose from when you later edit your pictures using your computer monitor.

# Project 9: indoor portrait using two lights

## 391 Step 1

As in the lighting setup for Project 4, a single light is fitted with a softbox and set up on a stand to the right of the camera, at about 45 degrees to the subject. As before, a silver reflector is positioned to the left of the camera.

## 392 Step 2

The second light is fitted with a snoot and positioned on a stand at about 45 degrees behind the subject. The stand is raised and the light angled downward so that the light reaches the top and side of the subject's head. It's worth checking that the light is not angled too much toward the camera position or this will cause flare in the lens.

## 393 Step 3

To measure the brightness of the hair light, position the light meter behind the subject's head with its Invercone pointed toward the light.

## 394 Step 4

Check that the hair light is not spilling over onto the subject's face. You can do this by turning off the frontal lighting and checking visually, or by taking a test shot.

## 395 Hair light output

We're all used to seeing people lit by light coming in several directions. In portraiture, using a hair light creates a natural lighting effect and helps to add a little separation between the subject and the background. The effect of the hair light can be varied by increasing or decreasing the output of the light. If your main exposure is, for example, f/11 then setting the hair light to f/8 would create a low-powered hair light effect. Increasing the hair light's output to f/16 would create a bright hair light effect. In the example here, the hair light was set to give the same light output as the main lighting.

# Project 10: reflective object

## 396 Reflections

Highly reflective products reflect their surroundings. This means if you stand in front of them with a camera and lights, your reflection will probably be visible in the object in the final shot.

## 397 White highlights

The more spherical the object, the more of its surroundings it will reflect. In general, broad white reflections look best in silver objects as it makes them appear shiny. The reflectors you use need to be large enough to fill the entire object; small reflectors will only create unattractive specula highlights (see tip 107).

## 398 Light tents

Professional photographers use a device called a "light tent" to shoot reflective products. A light tent covers the product all round in translucent fabric with just a small opening for the camera lens. The lighting is positioned outside the tent and provides an all-round soft light which reflects as white in the product. If you're not planning to take this type of shot all the time, the financial outlay for a light tent might not be justified.

## 399 Tabletop studios

A tabletop studio is a cheaper option than a light tent and makes lighting product shots easier. The studio has a translucent side panel and back and a silver reflector built into the other side panel.

## 400 Step 1

The cellphone was placed at the back of the "studio" to reflect as much of the white interior as possible, making the phone appear shiny.

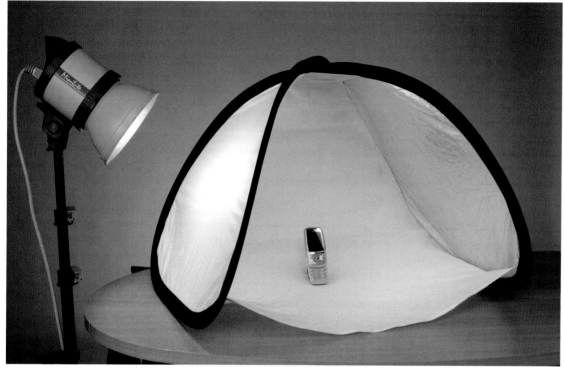

## 405 Step 6

The first test shot of the cellphone suggested that giving an extra 1/2 f/stop would make the phone appear brighter overall but compared to the rest of the phone, the keypad was looking quite dull.

## 406 Step 7

A sheet of white card about 18in square (45.7cm²) was positioned under the camera lens and angled upward at about 45 degrees to add sparkle to the phone's keypad.

## 401 Step 2

A single tungsten head with a dish reflector was positioned to light the phone through the translucent side panel.

## 402 Step 3

To avoid the orange glow from the low color temperature of the tungsten light source, a white balance was set manually using the camera's custom white balance function.

## 403 Step 4

To measure the brightness of the light falling on the subject, use a hand-held light meter with its Invercone pointed toward the camera.

## 404 Step 5

Both the camera's onboard light meter and a hand-held light meter will suggest an exposure to make the background gray. To correctly record it as white, you need to either set the exposure on the camera manually allowing +1 f/stop or use EV compensation set to +1 EV.

## 407 Step 8

When capturing the final shot in a setup like this, it's a good idea to bracket your shots in 1/2 or 1/3 f/stop increments as sometimes the camera's preview can be a little misleading. A picture that looks good on the camera might not be your preferred shot when the pictures are edited later.

# Project 11: outdoor portrait with a dramatic sky

##  Surreal sky

This dramatic lighting effect is often used by fashion photographers. You can use it in your portraits to create a slightly unnatural, surreal effect.

## 409 Step 1

To make this dramatic sky effect work properly you will need to shoot on a bright but cloudy day. Shooting in flat, overcast conditions will not produce the required effect.

## 410 Step 2

If you take a TTL meter reading of the sky and shoot a test picture, the sky will record normally. To create the dramatic stormy effect you need to underexpose the sky by -1 or -2 f/stops.

###  Step 3

Any subject that you place in the foreground will also be very underexposed and will need to be lit separately using flash.

### 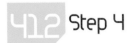 Step 4

Set the exposure on your camera to record the stormy-looking sky; this will be your main exposure.

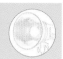

## 413 Step 5

Finally, set the output of the flash to match your main exposure, or for an even more dramatic foreground effect, experiment with setting the flash a little brighter than the main exposure.

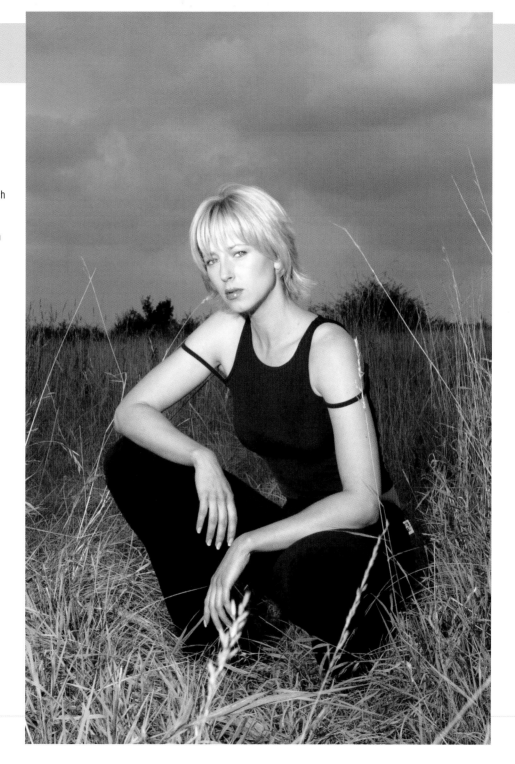

# Project 12: beauty lighting with two lights

## 414 Beauty lighting

Classic beauty lighting—sometimes called "butterfly lighting"—is often used by advertising photographers specializing in makeup and beauty shots. It is virtually shadowless and very flattering on the texture of skin. You need two lights and two reflectors to light the subject. In this example, two further lights have been used to create the white background (see Project 3).

## 415 Step 1

The first light is fitted with a softbox and positioned on a three-section light stand so that the light is almost immediately above the camera lens. A boom lighting stand makes this easier, but it's still possible with a straight stand; the light will just be a little off-center.

## 416 Step 2

Fit a softbox to the second light and place it at floor level, angled upward so that the light is pointed toward the subject. The shape of softboxes is ideal for this, without the need for any special stands.

## 417 Step 3

The lower light should be set to give 1 f/stop less output than the top light, although this is a matter of individual preference; some photographers like to set both lights to give the same output.

## 418 Step 4

To soften the light even farther, large 6½ x 3¼ft (2x1m) white reflectors are positioned at either side of the subject. You can use white card clamped to light stands or purpose-made panel reflectors; anything, in fact, as long as it fills the area between the softboxes with white.

## 419 Step 5

Use a light meter to take separate readings from the lights to ensure the bottom light isn't brighter than the top one, or your shot will look very unnatural.

## 420 Step 6

To check the cumulative effect of the lights and reflectors, take a meter reading from in front of the subject's face with the meter facing the camera.

## 421 Lighten the skin

The meter's exposure recommendation will produce a pleasing result, however some photographers prefer to overexpose a shot like this by up to +1 f/stop to create a lighter skin tone, but this is a matter of personal preference.

## 422 Setup variation

A variation of this lighting setup is favored by photographers who prefer a little more definition or modeling in their subject's features. This is achieved by replacing the white reflectors with black negative reflectors.

## 423 Remeter the setup

As the black surface absorbs some of the light that was previously bouncing around the setup, you will need to take another light meter reading and adjust the exposure as necessary.

# Postproduction lighting

## Image-editing software

Software offers photographers the ability to manipulate the appearance of the lighting in their digital photographs, by allowing them to edit both the brightness and quality of lighting in postproduction. This might be as a corrective measure, or purely for creative effect; the possibilities are almost limitless. This section is not intended to be a comprehensive guide to image-editing software, however, photographers often have to work in less than ideal lighting conditions, so we'll show you how to use software to achieve a range of postproduction lighting effects, from simple corrections right through to creative techniques that add a little sparkle to your pictures.

### Getting started

Before getting started with any image editing, you'll need to check you have suitable equipment, choose some software, and then look at a few basic ideas designed to get the best results from your manipulated pictures.

### Image quality

If you're going to correct or enhance your pictures, you will need to consider image quality. Digital cameras offer various settings that affect image quality. If you're just taking pictures to make small prints or to share online, low-quality small image files are ideal. However, if you're going to do more than use your software for a quick color correction, it's best to start with high-quality images.

### Pixels

Digital pictures are made up of pixels, which is short for picture elements. The imaging sensor (see tip 005) in a digital camera has a fixed number of pixels; millions of them in fact. Cameras, particularly cellphone cameras, are often described in mega pixels, for example a 3 mega pixel camera has 3 million pixels. DSLR cameras have a lot more pixels, typically 12 mega pixels. The number of mega pixels is the total number of pixels obtained by multiplying the width by the height of the sensor's pixels. A 4.5 mega pixel sensor produces an image file measuring 1,024 x 1,536 pixels.

### Resolution

The size of the pixels in an image file can be large or small. The term used to describe pixel size is resolution. The pixels in an image file are arranged by length, for example 72 pixels per inch (72 ppi), 150 pixels per inch (150 ppi), or 300 pixels per inch (300 ppi). In digital photography, pixels per inch is often described as dots per inch (dpi). Technically the two terms are different, but they are generally used interchangeably; dpi is the more common term. A file measuring 1,024 x 1,536 pixels could be arranged as $21^{1}/_{4}$ x $14^{1}/_{3}$ inches at 72 dpi or $5^{1}/_{16}$ x $3^{1}/_{4}$ inches at 300 dpi. The pixels in a 72 dpi image are obviously much larger than the pixels in a 300 dpi image. The following tips explain why this is important.

## 427 High resolution

If your digital image is made up of very small pixels, they won't be visible when you look at the picture, and because each picture element is so small, you'll be able to see very fine detail. Typically a picture with a resolution of 300 dpi is high quality and described as "high resolution" or hi-res for short. To reproduce a photograph in a glossy magazine would require a hi-res file.

## 429 File format

When you shoot a picture on a digital camera it's recorded on the image sensor and saved as an image file. There are various formats used to store pictures and these have a direct effect on image quality. There are three basic file formats: JPEG, TIFF, and RAW. You'll find them described in your camera's set-up menu as fine, high, medium, or standard image quality. If you want the best results from your postproduction image manipulation it's important to understand the effects file format has on a captured image file; the following points explain this.

## 428 Low resolution

If you don't intend to print your photographs, you might want to post them on the web or use them to sell items at an online auction site. If this is the case, you won't need a file made up of tiny pixels. Computer monitors can only display 72 dots per inch; technically this figure is either 96 dpi (Windows) or 72 dpi (Mac) but by convention 72 is used as the norm. A picture made up of 72 dpi is described as "low resolution" or lo-res. Lo-res pictures look fine viewed on a computer screen or television, but appear very blocky if you try to make prints from them.

## 430 Compression

To make file sizes smaller for use online or to fit more images on to a camera's memory card, files often need to be compressed. In the same way as video files can be converted to MPEG format and music files to MP3 format, picture files can be compressed to make them smaller. Compression can be either "lossy" or "lossless." Lossless simply means the file size is reduced without losing any image data. Lossy on the other hand means that some picture information is permanently discarded during the compression process.

## 431 RAW Format

Camera RAW records the information direct from the camera's sensor; there is absolutely no image processing applied in the camera. This option is usually only available to users of DSLR cameras. The RAW image data must be processed at a later stage to apply white balance, color saturation, and sharpening. Some photographers prefer this method of shooting as it allows them total control over what their final pictures look like.

## 432 TIFF Format

Camera set-up menus often refer to TIFF files as "high" or "fine" quality. The file is processed in-camera but the compression used is lossless, making its file size large. Unfortunately, large files take longer to save and need more space on a memory card. Given the choice, it's probably better to shoot using the highest quality JPEG for a processed image or Camera RAW for an unprocessed image rather than using the TIFF setting.

## 433 JPEG Format

The JPEG file format uses lossy compression to reduce file sizes. Areas of similar color or tone in a picture are compared and some image data is discarded permanently before the image is saved. When the file is reopened, the missing data is recreated by the software. In editing software, the amount of compression is applied when you save a file; this might be shown on a sliding scale numbered from one to 10, or as a percentage. For example, saving a JPEG at 30 percent would heavily compress the file making its file size a lot smaller but at the same time reducing its quality. A setting of 80 percent would produce a better quality image but result in a larger file size. Digital cameras usually offer fixed JPEG compression ratios described as fine, medium, or standard quality.

## 434 Saving JPEGs

Every time you save or resave a JPEG file, the compression is applied and reapplied until eventually, the image is completely degraded. If you're shooting JPEG files, download and convert your JPEGs into a lossless file format before starting any postproduction work.

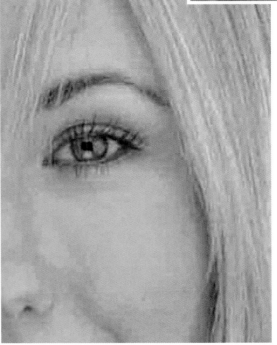

## 435 Choosing software

Some digital cameras and cellphone cameras are bundled with basic image-editing software. You can achieve good basic effects from this type of software; it's worth experimenting to see just what you can do. But remember once you save a file there's no going back. Adobe Photoshop is the image-editing software favored by photography and graphics professionals alike. Photoshop Elements is its fully-featured little brother, which shares all of the important functions of Photoshop but in an inexpensive package. In this section, we'll be using Photoshop Elements 5.

## 436 Personal workflow system

It's a good idea to establish a personal workflow procedure to avoid losing your valued digital pictures. Once you've downloaded image files from your camera, it's easy to mistakenly save something you were experimenting with. If you've deleted the shot from your camera's memory card, you won't be able to go back to the original, and the picture will be degraded or lost forever. Try downloading your pictures and burning them straight to CD ROM. You can then use this archive of camera files to work with, safe in the knowledge that your originals are safe. You can use the CD to copy the files you want to edit back on to your computer and then convert them to lossless TIFF files.

## 437 The right computer

Photoshop and Elements run on both PCs and Macs, provided the computer has enough processing speed and memory. Photoshop and Photoshop Elements require a fast processor and at least 512 megabytes (MB) of RAM, although 1,024MB (1 Gigabyte) is more efficient.

## 438 Graphics cards

Although both Photoshop and Elements are mainly used for postproduction work on digital photographs, from your computer's point of view they're basically graphics packages. As you look at your monitor and move an editing tool across your image, you need to see the effect instantly. This means that as well as the processing power required to make this happen, your computer has to constantly refresh its graphic output to the monitor. Therefore, for smooth running image editing, it's essential to have some dedicated graphics memory available to the computer. If you plan to do a lot of image editing, it's advisable to check the amount of graphics memory—sometimes called video RAM—you have available. Some computers, particularly cheaper laptops, share their processing and graphics RAM which can cause the whole system to run much less efficiently.

## 439 Scratch disks

In order to allow you to "undo" your image editing, Photoshop and Elements offer multiple levels of undo. This involves holding many versions of the edited file at the same time. To achieve this, the software uses the computer's hard disk drive (HDD) as a Scratch Disk; a sort of working area for temporary storage. The more empty HDD space you have available, the more efficiently the software will perform. If your computer has a second HDD it's a good idea to assign one for storing image files and the other for use as a scratch disk.

## 440 Launching Elements

Photoshop Elements 5 is a powerful imaging package. When you launch the software, you are presented with a menu screen offering a number of options, from organizing your picture folders through to editing your images. You can choose to use the full image-editing capabilities of Elements, or go straight to the very user-friendly Quick Fix section.

## 441 Editing options

Although the full editing mode offers users the most comprehensive set of image-editing tools, the Quick Fix option offers automated control of contrast and color as well as quick, user-friendly versions of some Photoshop tools. The more advanced features of Full Edit mode are covered later.

# Quick Fix mode

## 442 Elements workspace

Selecting either the Quick Fix or Edit and Enhance options will launch the Elements workspace known as the Canvas. This is where you'll work on your pictures. We'll start by looking at lighting adjustments using Quick Fix mode. You can change from Quick Fix mode to Full Edit mode by clicking the Tabs located at the top left of the workspace.

## 443 Opening a File

Always make a backup copy of the file you're going to edit then use File>Open to open the version of the picture file you want to work on.

## 444 Viewing your image

When a picture is captured using your camera in the upright (portrait) format, the file will need to be rotated 90 degrees. Use the Rotate Arrows at the bottom of the screen to rotate the image to the correct view. Remember not to click Save when you've rotated the picture as this will degrade your image by saving the file with more JPEG compression. Make sure you use the Save As command and change the file to a lossless file format like TIFF or PSD (see tip 446).

Rotate

## 445 Preparing to edit

Just to the left of the Rotate Arrows is a drop-down menu that allows you to alter the way you view the changes you make. The options are: After Only, which shows only the changes you make; Before Only, which doesn't show your changes; Before and After (Portrait), which shows both your original picture and the effect of any changes you make side by side; and Before and After (Landscape), which shows both your original picture and the effect of any changes, one above the other.

## 446 Saving your work

Remember to save your edited images regularly. Use the Photoshop standard PSD file format as a general rule. This format is uncompressed and allows you to save text and Layers within the file. If you want to use your pictures online or for printing, you can always convert PSD files to TIFF or JPEG at a later stage. The Save and Save As commands are located in the File Menu. Using Photoshop Layers will be covered fully in the section on Full Edit Mode (see tip 461).

## 447 Help is always at hand

Elements Quick Fix makes it easy to change the effects of the lighting in your pictures. To the right of the workspace there are a set of drop-down menus. Each has its own context-sensitive help section, which you can access by clicking its yellow lamp icon.

## 448 General Fixes

The General Fixes menu offers two automated options: Smart Fix and Red Eye Fix. Both have an Auto button. Smart Fix will try to correct the color and contrast in your picture all in one go; there's a slider to adjust the amount of correction applied. The Red Eye Fix is an auto only function which tries to detect red eye in a picture (see tip 169) and correct its effects. Depending on the picture you're trying to edit, both of these functions will produce some degree of success, but as you learn more about image editing, you will probably prefer to make your lighting corrections manually.

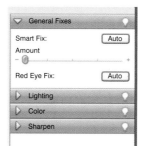

## 449 Reset

If you don't like the effects of the changes you make, just click the Reset button above the After preview and everything will revert back to how it was before you started.

## 450 Auto lighting

The Lighting menu lets you adjust both the level of brightness and the level of contrast in your picture. There are two Auto buttons that, depending on the picture you're trying to correct, will provide some degree of success. If you're not happy with the results, you can always use the Reset button.

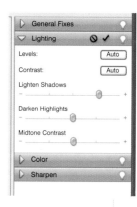

## 451 Manual lighting

In addition to its auto functions, the Lighting menu provides you with manual control of brightness levels within the picture. There are sliders to lighten shadows, darken highlights, and increase or decrease the mid-tones. In this example, the shadows along the side of the boat and under the bridge in the foreground have been lightened to reveal more detail. Darkening the highlights has made more of a feature of the sky; the mid-tones have not been adjusted.

# 452 Auto color

The Color Menu's Auto function is similar to the other Quick Fix auto options. Depending on the picture, Auto Color adjusts both the overall color and its depth. However, it's more likely that the manual control offered by this menu will produce a better effect.

# 453 Manual color

The Color menu has four sliders that allow you to increase or decrease the effects of each control. Saturation adjusts the intensity of the color; Hue alters the actual colors in the picture; the Temperature slider will make the picture warmer or cooler by adding red or blue; the Tint slider adds green or magenta.

# 454 Saturation

When you're working on an image, slight increases in color saturation can make the lighting appear much warmer, however larger increases will cause the picture structure to break up and degrade the image. Decreasing the saturation will produce more muted colors. At zero on the slider, all color will be removed leaving only shades of gray. In conjunction with the contrast controls in the Lighting menu, this is an easy method of converting your pictures to black and white.

# 455 Hue

Adjusting the Hue slider will change the colors across the spectrum. Global adjustments are best kept small to avoid unnatural colors.

# 456 Temperature

Starting at its mid-point the Temperature slider runs left to right, changing the color temperature from from blue to red. This is great for changing the lighting in a shot to alter its mood.

# 457 Tint

The Tint slider works in much the same way as the color temperature slider, but using a color range between green and magenta. This is useful for fine-tuning the effects of the color temperature control.

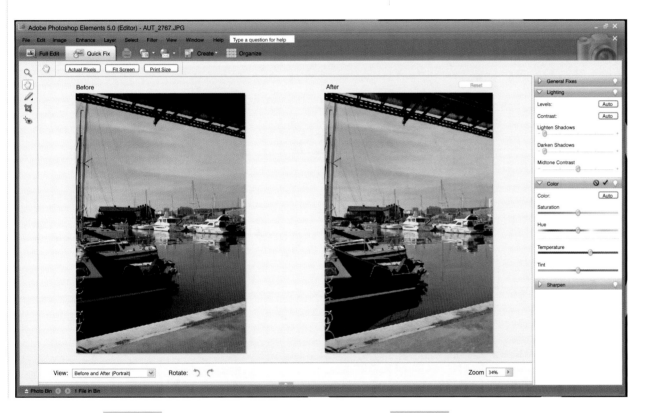

# 458 Unsharp Mask

The final Quick Fix menu is used to sharpen a picture. There are both auto and manual options for applying unsharp masking.

# 459 Quick Fix tools

To the left of the workspace is a small selection of editing tools: Zoom, Move, Crop, and a Red Eye Removal tool. The functions of these tools will be covered where necessary in the following section on Elements Full Edit mode.

# Full Edit mode

 Workspace

The Full Edit mode workspace is similar to the Quick Fix workspace but there is a more comprehensive selection of editing tools and no automated drop-down menus. You can flip between Full Edit and Quick Fix modes using the Tabs at the top of the workspace.

 Understanding Layers

One of the most important features of Photoshop and Elements is the ability to work in Layers. Layers are useful because they let you adjust your pictures, add extra components like text, and even edit individual elements without permanently changing the original image. Think of Layers as transparent sheets of glass or acetate placed one on top of another above your picture. You can write or paint on the "glass" and still see your picture through the transparent areas. At the bottom of the pile of Layers is the Background Layer which is usually your original picture.

## 462 Adjustment Layers

As well as the transparent layers used for adding pixel-based picture elements and text, you can add Adjustment Layers that enable you to alter the lighting color and brightness without making the changes permanent.

## 463 Saving layered files

Layered files can be saved using Photoshop's native PSD file format. As you might expect, using multiple Layers increases the size of the file, however if you're happy with a particular adjustment, you can merge Layers together. If you want, when you've finished editing you can flatten all the Layers using the command Layers>Flatten Image.

Palettes

In Photoshop graphical menus are called Palettes. The right-hand side of the Elements Workspace features an area called the Palette Bin. You can choose to show or hide the various palettes using the Window menu or drag them into the Palette Bin as a stack of drop-down menus. This is useful because if you have a lot of Palettes open on your workspace they can start to obscure the image you're trying to edit.

## 465 Layers palette

The Layers palette lets you create new empty Layers, view or hide individual Layers, and change the Layer order. When working on a picture, it's a good idea to keep the Layers Palette available at all times. You can do this by dragging it into the Palette Bin.

## 466 Undo History palette

Every change you make to a picture is recorded in the Undo History palette. By default, the Undo History palette will remember 50 previous states allowing you to undo any changes you're not happy with. The maximum number of History States can be changed to 1,000 but this will require an enormous amount of computer memory (see tip 439).

## 467 Histogram palette

A histogram provides a graphical illustration of a picture's exposure by showing the distribution of its highlights and shadows as a bar chart. Starting at level 0, the left side of the histogram shows the value for shadows, while the right side shows the highlight up to level 255.

## 468 Tonal range

The histogram can show if an image doesn't have a full tonal range; the most likely cause for this is that the picture was under or overexposed in-camera. An underexposed picture will produce a histogram with the pixels shifted more toward the shadows, while the histogram for an overexposed shot will be weighted toward the highlights. These examples demonstrate full tonal range; overexposure and underexposure. The following sections show you how to correct or adjust the tonal range in a poorly exposed picture.

# Auto lighting adjustments

## 469 Enhance menu

The Enhance menu provides a number of automated functions for altering the tonal range in a picture. As with the solutions offered in Quick Fix mode, the success of these functions varies from picture to picture. Additional commands allow a degree of manual control over the automated features. The following tips look at the auto functions in detail.

## 470 Smart Fix

Smart Fix tries to correct the overall color balance in the picture and, if necessary, adjusts shadow and highlight detail.

## 471 Auto Levels

If an image needs more contrast and has a color cast, Auto Levels will make the lightest and darkest pixels in each of the red, green, and blue color channels, black and white.

## 472 Auto Contrast

Auto Contrast adjusts the overall contrast of an image without affecting any of the colors. This works best when your image needs more contrast, but the colors look right. Auto Contrast changes the lightest and darkest pixels to white and black respectively; resulting in brighter highlights and darker shadows.

## 473 Auto Color Correction

This auto function tries to identify areas of shadow, mid-tone, and highlight and resets them to Elements' default values.

## 474 Adjust color for skin tone

This command is useful for adjusting the lighting to give your subjects a more appealing skin tone. When you launch the Adjust For Skin Tone dialog box, make sure the Preview box is checked so you can see the changes you make. Position the cursor over an area of skin tone in your picture and click. Elements will try to adjust the color automatically; however the effect is often too subtle. It's more effective to click an area of skin and use the sliders to manually fine-tune the color. Tan increases or decreases the level of brown in the skin tones while Blush increases or decreases the level of red. You can use the Temperature slider to adjust the overall color of the image's ambient lighting. If you are unhappy with your result, just click the Reset button and start again.

# Manual lighting adjustments

## 475 Manual Control

Creating an adjustment layer (Layers>New Adjustment Layer) provides you with by far the most control over picture adjustments, and because the changes are on separate Layers (see tip 461), you're not committed to using them; any changes you make are not permanent until you flatten and save the file (see tip 463).

## 476 Levels

Using this command creates a new Levels Adjustment Layer in the Layers Palette and displays a histogram for the image. You can use the sliders to adjust highlight, mid-tone, and shadows for the overall file or for the separate red, green, and blue color channels. The example here shows a slightly underexposed image, which is easily adjusted by moving the highlight slider to the left to redistribute the picture's tonal range.

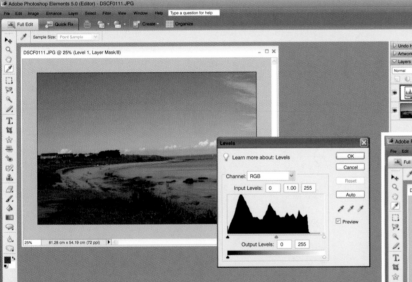

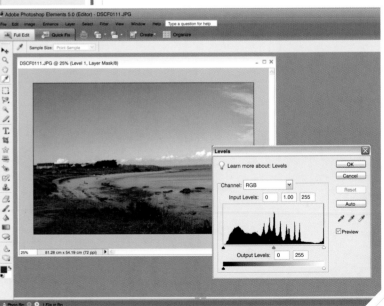

# 477 Contrast

This command creates a new Brightness/Contrast adjustment layer in the Layers palette. You can use its controls to adjust the brightness of an entire image or to reduce its overall contrast. The sliders adjust the brightness and contrast; dragging to the left decreases the contrast level while dragging to the right increases it. The brightness and contrast values are displayed in the range -100 to +100.

# 478 Color

You can use the Hue/Saturation command to adjust the hue (color), saturation (density), and overall lightness of an entire image, or to adjust individual colors within an image. The Hue slider can be used to color a black-and-white image or to change the range of colors in part of an image. The Saturation slider makes colors more vivid or muted, which is great for adding punch to the colors in a landscape or toning down a distracting color in a portrait. Don't use the Lightness slider on its own as it will just reduce the picture's overall tonal range; lightness is best used to lighten or darken specific areas within a picture. In the example below, both the overall Hue and overall Saturation sliders have been adjusted to "push" all tones in the image. By selecting a specific color from the drop-down menu, such as Blues, the adjustments could have been applied only to that selected color.

# 479 Filters

The Photoshop Photo Filters can be used to mimic the effects of using traditional glass or resin filters in front of your camera's lens. But unlike traditional filters, these software versions are applied after a shot has been taken, rather than being committed to the shot at the time it's captured. The drop-down menu offers traditional Wratten warm up and cool down filter effects such as 80 and 81, as well as special effect filters like sepia and underwater. Selecting the Preview option allows you to see the effect of each filter as you select them, while the Preserve Luminosity option preserves the picture's tonal range after the filter has been applied. The Density slider adjusts the amount of color applied to the picture; use it to vary the effect of the filter. Selecting the Color option allows you to create your own filter by defining a customized color.

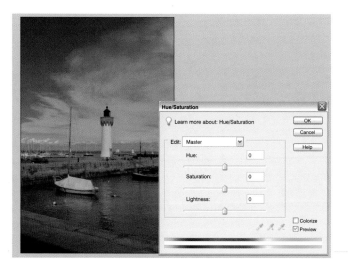

# Selective lighting adjustments

Up to now we've looked at making postproduction lighting adjustments that affect the whole of an image. In this section, we'll look at how to use a selection of Elements' editing tools to make adjustments to selected areas within an image.

## 480 Tools palette

By default, the Tools palette is locked to the left-hand side of the Elements Workspace. However, for convenience, it can be dragged wherever you want on the Workspace.

## 481 Color Picker

At the bottom of the Tools palette are two squares which show the current foreground and background color selections. The two headed arrow switches between them. Clicking into either square launches the Color Picker, which lets you choose the foreground and background colors.

## 482 Selecting brushes

When you're working with Elements tools, you will often need to select a Brush Tip to "paint" the lighting adjustments into small specific areas of your image. Brush Tips are selected from a drop-down menu and their sizes are described in pixels. Many of Elements' tools use a graphic of the tool as a cursor while you brush, draw, or paint with them. However for more control, it's best to change the tool tip to display the actual size of the brush you're using. To do this, go to Edit>Preferences>Display & Cursors and select the Full Size Brush Tip and Precise cursor options.

## 483 Color Replacement tool

The Color Replacement tool is located in the Brush menu. Selecting the Brush tool in the Tools palette opens the Brushes menu at the top of the workspace. You'll find the Color Replacement tool nested among the Brush styles. Use the Brush menu to select an appropriate brush size for the area you want to work on, and choose one of the color selection options. The Sample Once option has been used in this example to select the blue tone of the sky. As the 184 pixel brush is moved across the sky, any blue tones are changed to the purple foreground color (see tip 481), while all other tones in the image remain unchanged.

# 484 Dodge tool

The Dodge tool is part of a nested tool menu which offers a selection of tools that work in a similar way to traditional darkroom techniques. When photographers make prints in a darkroom, they often use a small cardboard "dodging" tool to hold back the light reaching some of the darker parts of their print to make those areas lighter. The Elements Dodge tool is used to lighten mid-tone or shadow areas in an image as you move the brush across a selected area.

# 485 Burn tool

Like the Dodge tool, the Burn tool owes its name to the darkroom technique of giving highlight areas of a print a bit more exposure to make them darker. The Burn tool is useful for bringing out details in highlights, but you can also use it to darken mid-tone and shadow areas. The Exposure box determines the effect of the Tool for each brush stroke; to lighten an area gradually, set a low exposure value and brush the area several times. In this example, the mid-tones were darkened to create the flower design on the subject's T-shirt.

# 486 Sponge tool

While the Dodge and Burn tools let you lighten or darken areas within an image, the Sponge tool works with color saturation. The Sponge tool options are Saturate or Desaturate, which means you can use it to strengthen or mute the effects of any color in your picture. In Grayscale (black and white) mode, the tool increases or decreases contrast. The number in the Flow box sets the rate of saturation change, lower percentages make more subtle adjustments.

# Advanced lighting adjustments

The previous sections have looked at making adjustments to the lighting in a picture using Elements' automated functions and a selection of basic adjustment tools. In this section we'll look at a few techniques for making more advanced adjustments.

## 487 Creating Adjustment Layers

You can create a new Adjustment Layer using either Layers>New Adjustment Layer, or by clicking the New Adjustment Layer button in the Layers palette. To adjust the lighting in your images, choose Levels, Brightness/Contrast, Hue/Saturation, or PhotoFilter. The difference between using these controls on a separate Layer and their automated functions is that individual Layers can be modified or removed without affecting the basic image. You can show or hide the effects you've created by clicking the Eye symbol next to the Layer's thumbnail in the Layers palette.

## 488 Layer Masks

When you adjust the lighting in an image using an Adjustment Layer, you can fine-tune its effect or limit the area it affects by using a Layer Mask. Each time you create a new Adjustment Layer, a Layer Mask is automatically linked to it in the Layers palette.

## 489 Using a Layer Mask

When a Layer Mask is filled with pure white, the Adjustment Layer is fully applied to all Layers below the Adjustment Layer. To remove the effects of the Adjustment Layer, fill the mask with pure black. To selectively remove the effect of an Adjustment Layer, use any of the painting tools and paint the area you wish to hide or reveal. Painting a mask with gray mutes the effect of the Adjustment Layer.

## 490 Corrective lightening example

Your camera's metering system will try to record a black subject as mid-gray, which will result in an overexposed picture. Using exposure compensation in your camera, or a separate light meter and manual exposure control, will produce a better result, but even in bright sunlight, very dark subjects tend to absorb a lot of light. Although this picture is correctly exposed, parts of the dog's face are too dark and lack detail. Use the command Layers>New Adjustment Layer>Levels to create a Levels Adjustment Layer and Layer Mask. Adjust the sliders on the Levels histogram to lighten the whole picture until the shadow areas appear correct. Use the Color Picker (see tip 481) to select black as the foreground color and the Paint Bucket Tool to fill the Layer Mask with black to revert back to the picture's original brightness levels. Now select white as the foreground color and use the Paintbrush tool to paint white into the Layer Mask in the areas of the dog's face you want to lighten.

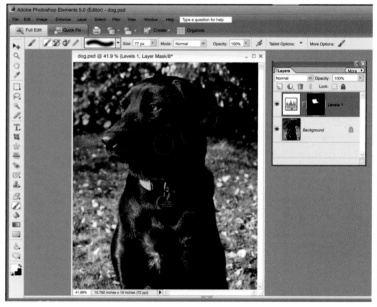

## 491 What is a selection?

A selection is an area of a photograph you want to work on without affecting the rest of the picture. The edge of a selected area is defined by a dotted line, sometimes described as looking like "marching ants." You can work on the pixels inside the selected area, but you can't do anything to any part of the picture outside the selection until you use the Deselect command, Select>Deselect.

## 492 Inverting a selection

The command Select>Inverse inverts a selection. This means that the selected area is outside the Selection Border where previously the selection was inside.

## 493 Selection tools

Elements contains a number of Selection tools that are suitable for making different kinds of selections. For example, the Rectangular Marquee tool selects square or rectangular shapes, while the Magic Wand tool is used to select areas of similar color with just one mouse click. More complicated shapes can be selected using the Lasso tools. In the example on the right, the Magic Wand tool has been used to select the color of the backdrop. The tool's Tolerance setting has been set to 20 pixels to ensure only colors very similar to the background are selected.

## 494 Feathering

The edges of selections are generally quite hard, which can look unnatural, however you can smooth selection edges by feathering them. Feathering blurs selection edges by creating a transition between the selection edge and its neighboring pixels. In the example on the left, the selection was feathered by three pixels before a Hue/Saturation Adjustment Layer was added to change the color of the backdrop.

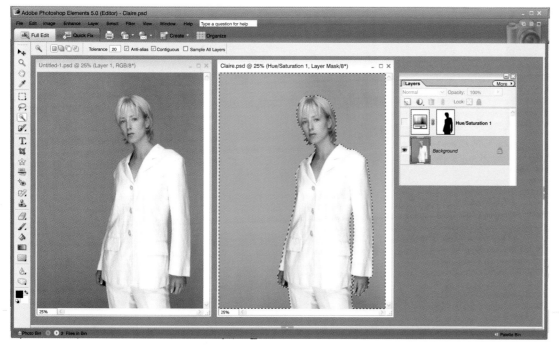

# 495 Lighting effects filters

Both Photoshop and Elements offer a range of very useful lighting effects filters which you can use to simulate quite complicated studio lighting setups. The lighting filters are accessed using the command Filter>Render>Lighting Effects. In addition to the Default setting, which adds a medium intensity white spotlight, there are a large number of preset lighting effects using up to five lights, or you can create your own setups. The Preview window shows you the effect of each light so you can test different setups before deciding which one to keep.

# 496 Dramatic backlighting

To avoid making permanent changes, create a duplicate of the main image Layer. Use the command Layer>Duplicate Layer and call this new Layer "Lighting." Applying a lighting filter to the entire image will create a foreground lighting effect, so to give the impression that the light is behind the subject, you'll need to make a selection round the subject. In this example, there's already a selection in the Hue/Saturation Adjustment Layer, so hold the Ctrl key and click the Layer Mask to reselect it. The inside of the selection is now protected from the effects of the filter. Launch the Lighting Effects Filter using Filter>Render>Lighting Effects. For the background effect, a white Flashlight was used with an Omni style which simulates a large soft light source. The Preview window ignores the selection, so the preview effect will show a foreground light. Click OK when you're happy with the lighting effect. If you don't like the effect you can always use Edit>Undo or go back a step in the Undo History palette. Use Select> De-Select to remove the selection. Enlarge the picture on your monitor using View>Actual Pixels and check the edges of the mask, if necessary you can fine-tune the edges by painting with either black or white.

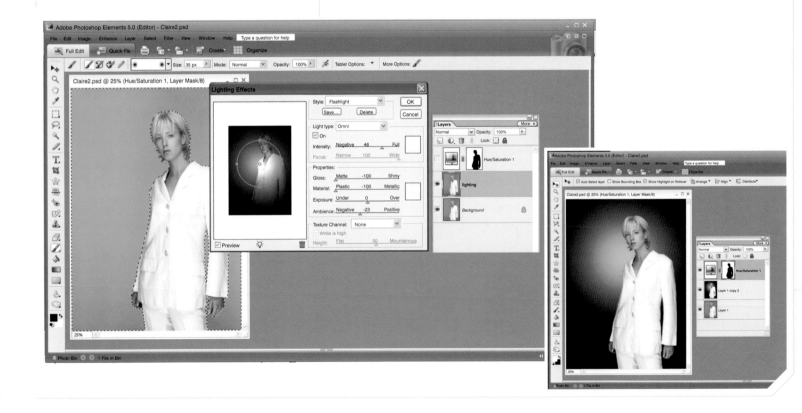

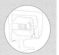

# 497 Lens Flare filter

The Lens Flare filter is probably one of the most popular Photoshop effects filters. You can use it to recreate the flare caused by shooting directly into a bright light, like the sun. The dialog box lets you choose the type of lens, the position, and the brightness of the flare. If you're going to use the Lens Flare filter remember that, once you've clicked OK in the preview dialog box, the flare will appear on your picture; you have no farther control over it. The following example will show you a way around this.

# 498 Lens Flare example

There are several techniques you can use to give you more control over the Lens Flare filter; this is one of the simplest. Create a new Layer, in the dialog box change the mode to Screen and then click the Fill with Screen-neutral Color (black) option. In the Layers palette you'll see a new Layer filled with black but there will be no visible effect on the image. The effect of using Screen mode is like projecting several photographic transparencies on top of each other. However, if you Screen with black, the color of underlying Layers is not affected. Next, apply the Lens Flare filter to the new black Layer. The result will be that the Lens Flare is on its own Layer and can be dragged into any position you want. Finally, a Levels Adjustment Layer has been added to lighten the quayside in the foreground. To achieve a smooth transition between the light and dark areas, use the Color Picker to set the foreground and background colors to black and white and use the Gradient Tool to fill the Layer Mask.

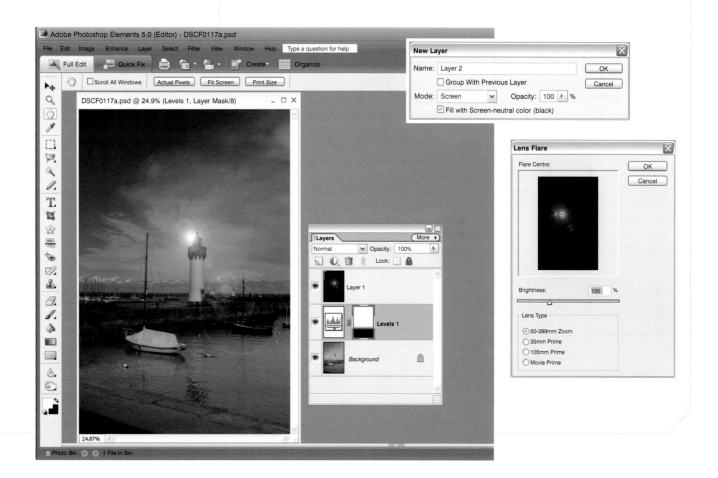

# 499 Creating moonlight

Creating a dramatic moonlit shot from a daylight image is easy. To avoid making permanent changes to your picture, start by adding a duplicate background layer and call it "Moonlight." Use the Lighting Effects filter to create the moon. In this example, the moon effect has been achieved using a spotlight setting in Omni mode. A natural moonlight glow requires the Ambient lighting slider to be set to +10 and the Exposure slider to +53. The reflection in the sea was painted in using the Dodge tool set at 20 percent Exposure with a 200 pixel soft-edged brush. To give the image an overall nighttime glow, a new Fill Layer was added using the Layer>New Fill Layer>Solid Color command. The new Layer was set to Overlay mode and filled with dark blue. Overlay mode places a color over the entire picture but preserves the highlights and shadows from the original image. The original image is mixed with the overlay color to reflect the lightness or darkness of the original color. Finally, a Levels adjustment Layer was included to lighten just the bottom left-hand corner of the picture. The Layer Mask was filled using the Gradient Tool (see tip 498).

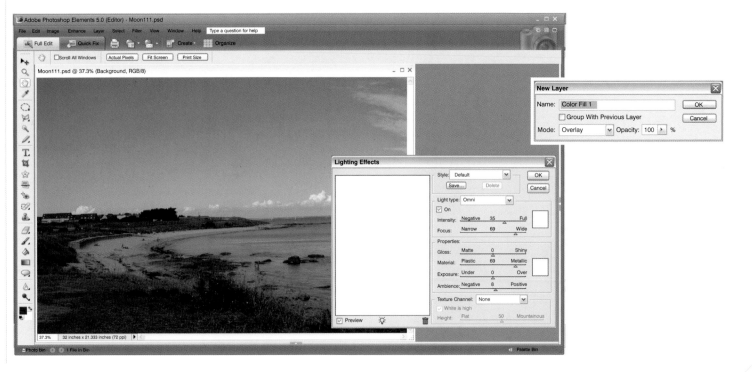

# 500 Combining techniques

Achieving an overall lighting effect in postproduction often requires a combination of adjustment techniques. This image requires six adjustment layers to achieve the final result. To start with, an overall Levels Adjustment Layer evens out the tonal range of the picture. A second Levels Adjustment Layer with a Layer Mask is then used to darken only the background around the subject. In the original shot, the red guitar is far too saturated so a Hue/Saturation Layer is added with a Layer Mask to keep the adjustment to just the guitar. The Layer Mask is then reloaded as a selection using Ctrl+Click and another Levels Layer added to slightly lighten the guitar. The shafts of light are created using the Polygonal Lasso tool to select a diagonal oblong; the edges of the selection are blurred by feathering them 50 pixels. A further Levels Layer is then added and the mid-tones lightened to make the area inside the selection appear brighter. The shaft of light was then duplicated using Layer>Duplicate Layer and dragged down the image using the Move Tool to create the second shaft of light. Finally, the Paintbrush Tool was used to paint gray into the Layer Mask for Shaft 1 to blend its effect with the subject's T-shirt.

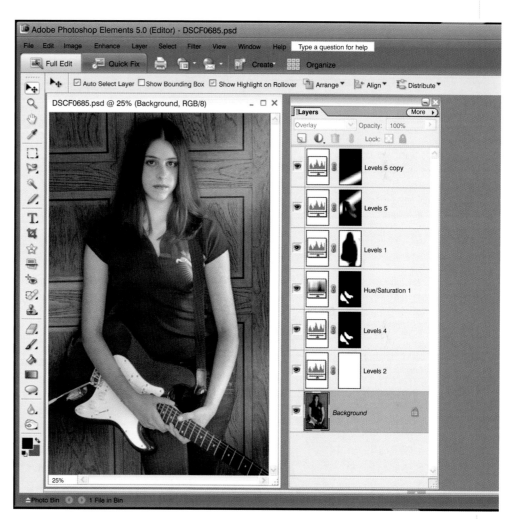

# Glossary

**Accent light**
Light used to brighten or highlight a localized area of a subject.

**Acetate**
See gel.

**Ambient light**
Naturally occurring light.

**Available light**
See Ambient light.

**Barn doors**
Adjustable set of flaps that attach to the front of an artificial light source to control the spread of its light.

**Bean bag**
Camera support that can adapt its shape to various situations where a steady camera is essential. Usually a fabric bag filled with dried peas, plastic beads, or similar.

**Boom**
A lighting stand primarily designed for use in a horizontal position.

**Brolly**
See Umbrella.

**CCD (Charge-coupled device)**
An image sensor, comprising an integrated circuit with an array of linked, or coupled, light-sensitive capacitors. Also known as a color-capture device.

**CC filters**
Color correction filters used for correcting any imbalance between films and light sources. CC filters are less useful in digital photography as digital cameras have a white balance setting.

**Color temperature**
The color of light measured in degrees on the Kelvin (K) scale.

**CMOS (Complementary metal oxide semiconductor)**
A major class of integrated circuits, used for a wide variety of microprocessors and analog circuits, such as image sensors.

**Continuous lighting**
Sources that provide steady illumination, in contrast to flash which only fires briefly.

**Diffuser**
Any kind of accessory which softens the output from a light.

**DSLR (Digital single-lens reflex camera)**
A type of camera that allows you to see through the camera's lens as you look through the viewfinder.

**Effects light**
See Accent light.

**EV (Exposure Value)**
The number given to represent the brightness value of various shutter speed and aperture combinations at a given film speed.

**Fill light**
Light or reflector designed to reduce shadows.

**Fish fryer**
Extremely large softbox.

**Flag**
Sheet of black card used to prevent light falling on parts of the scene or entering the lens and causing flare.

**Flash head**
Studio lighting unit which emits a brief and powerful burst of daylight-balanced light.

**Fluorescent light**
Continuous light source which often produces a green cast with daylight-balanced film, although neutral tubes are also available.

**Fresnel**
A type of lens invented by Augustin-Jean Fresnel (pronounced fre-nel). Originally developed for lighthouses, a Fresnel lens has a large aperture and short focal length but is much thinner and passes more light than a conventional lens.

**Gels**
Colored filters used on light sources for color correction or for creative effect.

**Giraffe**
Alternative name for a boom.

**Gobo**
Sheet of black card or metal with areas cut out, designed to cast shadows when fitted over a light.

**Grid**
See Honeycomb.

**Hair light**
See Accent light.

**Honeycomb**
A grid that fits over a lighting head to slightly soften the harsh direct light over a small area of the subject, perhaps as an accent light.

**Hotshoe**
An accessory shoe attached to a camera. A hotshoe is "hot" because it contains the electrical contact used to trigger flash guns.

**Incident reading**
Exposure reading of the light falling onto the subject.

**ISO (International Standards Organisation)**
An international organisation that coordinates agreement on industrial standardization.

**Joule**
Measure of the output of flash units, equivalent to one Watt-second.

**Kelvin**
Scale used for measuring the color of light. Daylight and electronic flash is balanced to 5,500 K.

### Key light
The main light source in a lighting setup.

### Kick light
See Accent light.

### Kill spill
See Spill kill.

### Light tent
A translucent dome of fabric that fits over a small reflective subject such as a piece of jewelry, to avoid unwanted reflections.

### Mixed lighting
Combination of different light sources, such as daylight, flash, tungsten, or fluorescent.

### Modeling lamp
Tungsten lamp on a flash head which gives an indication of where the illumination will fall.

### Monobloc
Self-contained flash head that plugs directly into the mains (as opposed to flash units that run from a power pack).

### Multiple flash
Firing a flash head several times to achieve a required amount of light.

### Multi pop
See Multiple flash.

### PC connector
Circular connector socket on a camera body for attaching a flash sync cable.

### Power pack
Separate control unit containing capacitors and output controls that can be connected to one or more flash heads.

### Ratio
Difference in the amount of light produced by the various light sources in a setup.

### Reflector
A metal shade round a light source to intensify, contain, or direct it. Also, a surface used to bounce light around.

### Ringflash
Circular flash tube which fits around the lens and produces a characteristic shadowless lighting.

### Seamless backdrop
Fabric or paper backdrop gently curved at ground level to avoid an obvious horizon line.

### Slave
Light-sensitive cell which synchronizes the firing of two or more flash units.

### Snoot
Black tapered cone used to concentrate light into a circular beam.

### Softbox
Popular lighting accessory producing extremely soft light. Various sizes and shapes are available—the larger they are, the more diffuse the light.

### Spill
Unwanted light "spilling" around a lighting setup.

### Spill kill
Accessory fitted to a flash head to prevent backward spill when using an umbrella.

### Spot
A directional light source.

### Spot meter
Meter capable of reading reflected light from a small area of the subject.

### Stand
Support for lighting equipment and cameras.

### Swimming pool
Large softbox giving extremely soft lighting (see also Fish fryer).

### Sync cable
Cable for connecting a camera and flash unit together to synchronize the camera's shutter with the flash.

### TTL
This stands for through-the-lens metering.

### Tripod
Three-legged camera support.

### Tungsten
Continuous light source produced by a tungsten filament lamp.

### Umbrella
Accessory for creating reflected light from an artificial light source. Available in white (soft), silver (harsher light), and gold (warming). The larger the umbrella, the softer the light.

### White balance
Digital camera's reference point for the color of white light. Once set for lighting with a particular color temperature, the camera will calculate all other colors based on this white point.

### Wratten filters
Named for Frederick Wratten, an English inventor who first specified a standardized set of photographic filter colors. The Wratten Company was purchased by Kodak in 1912 and the filters became known as Kodak Wratten filters.

# Index

# Acknowledgments

With a very special thank you to my wife Sandra for her patience, and her invaluable input and assistance in producing this book.

A huge thank you also to the following for their help and support with this project: Sarah Belizaire-Marron at Midnight Communications, Chris Coleman at Newpro UK, Fraser Downie at The Flash Centre UK, Kathy Edgeley at JP Distribution, Ernie Fenn at Sto-fen.com, Richard Horley at Richard Horley Lighting, Mark Langley at Lastolite UK, Caroline Lees at Fuji Film UK, Jerry Lunn at Hama UK, Thom Pahmer at Pod Industries Canada, Paul Reynolds at Sigma Imaging UK, Keith Sanderson at Johnsons-Photopia UK, and Chris Whittle at PSC Ltd.

The publishers would like to thank Fineline Studios for all their hard work on the design of the book.

All photographs in this book copyright Rod Ashford unless captioned otherwise.